IMAGES
of America

THE PRESIDENT
WOODROW WILSON HOUSE

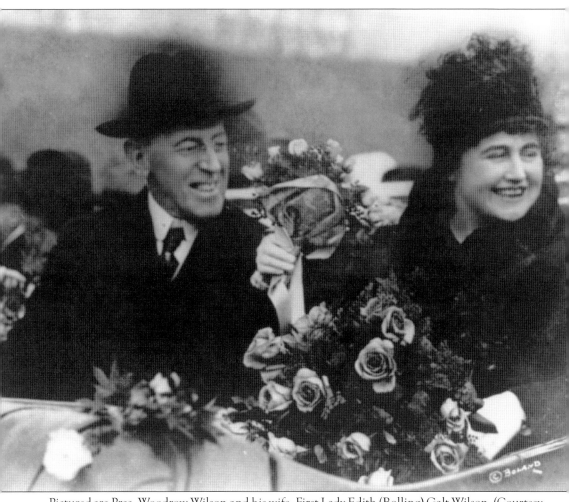

Pictured are Pres. Woodrow Wilson and his wife, First Lady Edith (Bolling) Galt Wilson. (Courtesy of Library of Congress.)

ON THE COVER: Woodrow Wilson is seen on the front steps of his home at 2340 S Street NW, Washington, DC, which is today the President Woodrow Wilson House, on Armistice Day, November 11, 1922. (Courtesy of Library of Congress.)

IMAGES
of America
THE PRESIDENT WOODROW WILSON HOUSE

Elizabeth A. Karcher
National Trust for Historic Preservation
Foreword by Cary C. Fuller

Copyright © 2024 by Elizabeth A. Karcher, National Trust for Historic Preservation
ISBN 978-1-4671-6124-4

Published by Arcadia Publishing
Charleston, South Carolina

Printed in the United States of America

Library of Congress Control Number: 2024933425

For all general information, please contact Arcadia Publishing:
Telephone 843-853-2070
Fax 843-853-0044
E-mail sales@arcadiapublishing.com

Visit us on the Internet at www.arcadiapublishing.com

Dedicated to my loving husband, Arthur Cohen. You are everything.

Contents

Foreword		6
Acknowledgments		7
Introduction		8
1.	The Making of a Visionary Leader	11
2.	An Unprecedented First Lady	19
3.	Progressive-Era Politics	25
4.	Three Weddings and a Funeral	41
5.	Wilson and Race	49
6.	World War I, Paris, and Wilson's Vision for Peace	61
7.	The Wilsons Retire to Washington	85
8.	Life on S Street	101
9.	Preserving Wilson's Legacy	113
10.	The Museum's Collection	123
Bibliography		126
About the Organization		127

Foreword

I grew up in this house, as my great-aunt was Edith (Bolling) Wilson. She lived here until I was a freshman in college, so I am fortunate to have personal memories of 2340 S Street. This historic residence, nestled in the heart of Washington, DC, holds within its walls a wealth of memories and moments that resonate with the spirit of a bygone era. It is a place where history is not just documented, but lived and breathed.

My recollections are a tapestry of cherished moments spent within these hallowed halls— playing canasta with my great-aunt, savoring holiday dinners, and witnessing the arrival of the incomparable First Lady Jacqueline Kennedy, who came to have lunch with Aunt Edith. It was here that I had the privilege of witnessing the last social engagement Edith attended before her passing on December 28, 1961. That day held special significance, for it marked the 105th anniversary of Woodrow Wilson's birthday and was meant to be the occasion when she dedicated the Woodrow Wilson Bridge in Washington, DC.

Throughout the years, I have watched this house transform into the remarkable Woodrow Wilson House Museum. It has been a journey of dedication, perseverance, and unwavering commitment. Elizabeth Karcher and her team have poured their hearts and souls into preserving this historic gem, ensuring that it remains a place that matters, where the legacy of President Wilson and the enduring spirit of his time continue to inspire and educate.

The photographs within the pages of this book capture the essence of 2340 S Street, offering a visual journey through its rich history. I hope you will visit. You, too, will appreciate the profound significance of this house and its role in preserving the legacy of Woodrow Wilson.

Sincerely,

Cary C. Fuller

Acknowledgments

Bringing this project to fruition has been a journey that could not have been undertaken alone. To those who have contributed their time, expertise, and support, I extend my heartfelt gratitude.

First, my appreciation goes to the President Woodrow Wilson House and its dedicated staff: Felice Herman, Edith Michel, and John Pucher, and the guides, scholars, volunteers, and advisory council members, in particular the executive committee: chair Cosby Hunt, Cary Fuller, Ed Gerber, Chris Keller, and Amanda Innes, as well as to the National Trust for Historic Preservation. Their unwavering commitment to historical preservation, education, and the legacy of Woodrow Wilson has been the bedrock upon which this endeavor has been built. All images used in this book come from the Woodrow Wilson House Collection or the Library of Congress unless otherwise noted.

To the scholars, and foremost, Chris Conte, whose meticulous work has illuminated the pages of this book, I am indebted. Your passion for unearthing hidden truths and contextualizing historical events has enriched the narrative and deepened our understanding of Woodrow and Edith Wilson's legacy.

My profound thanks to Dr. John Milton Cooper, Jr., for reading and editing this book. I am honored and privileged to have a Wilson expert comment and work through the draft with me. Thank you.

Sincere thanks to Arcadia Publishing, Katelyn Jenkins, and Caitrin Cunningham for their guidance, partnership, and commitment to preserving and sharing our history. Your support has been invaluable in bringing this project to fruition.

A special acknowledgment goes to my family and friends, whose unwavering support, encouragement, and understanding sustained me throughout the journey of taking on the role of executive director of this incredible museum and creating this book.

Lastly, I dedicate this work to Edith Wilson, the steward, curator, and visionary of preserving the legacy of a world leader, and to Woodrow Wilson himself, a man whose leadership, ideals, and complexities continue to resonate through the passage of time. May his legacy inspire us to engage with history, embrace dialogue, and work toward a better world for everyone. We are all citizens of the world.

INTRODUCTION

Welcome to a captivating exploration of one of America's hidden treasures: the President Woodrow Wilson House. Nestled in the heart of Washington, DC, this historic home offers a unique glimpse into the life and legacy of one of America's most influential presidents. Our journey will transport you back in time, unraveling the stories, the triumphs, and the challenges that shaped Woodrow Wilson's remarkable story.

On March 4, 1921, Woodrow and Edith Wilson moved out of the White House and into their new home—just a mile and a half away—at 2340 S Street NW in DC's Kalorama neighborhood. The former president lived at the S Street house until his death in 1924. Edith called the mansion home until her passing in 1961, at which time she bequeathed the house and its furnishings to the National Trust for Historic Preservation to serve as a monument to President Wilson.

Completed in 1916, the Wilsons' new, very modern home and stately gardens were designed in the Georgian Revival style by renowned architect Waddy Butler Wood, who also designed the home next door. Originally built as the private residence for Henry Parker Fairbanks, an executive at the Bigelow Carpet Company, the S Street house combines classic design with then-modern necessities. Along with a marble entryway and grand staircase, Palladian windows, book-lined study, and a solarium overlooking the formal garden, the house also boasts a dumb waiter, elevator, and butler's pantry, a telephone intercom system, and a kitchen stocked with the latest gadgets of the day.

The S Street house has been maintained much as it was in 1924, including furniture, art, photographs, state gifts, and the personal effects of the president and First Lady. The library includes a century-old Steinway concert grand piano that President Wilson had in the White House, a framed mosaic that he received on his trip to Italy in 1919 from Pope Benedict XV, and a wall-sized Gobelin tapestry presented by the people of France following World War I.

Before President and First Lady Barack and Michelle Obama, the Wilsons were the only president and First Lady to make Washington their permanent home after leaving office. In retirement, the Wilsons received dignitaries and guests at the home, including former British prime minister David Lloyd George and former French prime minister Georges Clemenceau.

The house opened as a museum in 1963 honoring the legacy of Woodrow Wilson. Wilson's time in the White House—and its impact generations after—is rife with paradoxes and contradictions. His progressive "New Freedom" platform envisioned an active federal government as a force for equity, and yet that vision largely excluded African Americans. Celebrated for advancing democracy and freedom abroad, many of Wilson's domestic policies sometimes helped to entrench racial segregation and injustice at home, restricting the rights and privileges of African Americans, women, and immigrants.

An accurate and full account of the Wilson era reveals the systemic injustices we continue to confront to this day. At the same time, understanding Wilson's role in defining and leading a new dawn in 20th-century international relations is vital to understanding those dynamics in the 21st century. The Woodrow Wilson House is committed to listening to and leading these important civic discussions. As a hub for both public museum exhibitions and scholarly engagement with

Wilson's legacy and the Progressive Era, the Wilson House aims to be a space of reconciliation and healing through an honest, dynamic exploration of the past and the present.

Each chapter of this pictorial review of the President Wilson House is crafted to reveal a focused portion of the story of the museum, illuminating its architecture, its treasures, its mission, and its vision.

Whether you are a history enthusiast, a student of presidential studies, or simply curious about the intricate layers of our nation's past, this book aims to captivate and educate. It examines the remarkable legacy of Woodrow Wilson, a man whose vision shaped not only his time but the trajectory of our country for the past century.

One

THE MAKING OF A VISIONARY LEADER

Woodrow Wilson was the visionary leader whose footsteps echo through the halls of the President Woodrow Wilson House. This chapter explores the early years, the transformative presidency, and the enduring impact of a man who shaped the course of American history.

Born on December 28, 1856, in Staunton, Virginia, early in life Thomas Woodrow Wilson enjoyed the bucolic charm of the American South, a region steeped in tradition and history. Wilson was shaped by the influences of his Presbyterian minister father and the academic pursuits of his mother. From an early age, his insatiable thirst for knowledge propelled him on a remarkable intellectual journey. In 1885, he married Ellen Axson, an impressionist painter who trained at the New York Academy of Design. The pair had three daughters: Margaret, Jessie, and Eleanor.

With an unwavering determination and an unfaltering commitment to education, Wilson climbed the academic ladder, eventually becoming president of Princeton University, where he championed progressive educational reforms and left an indelible mark on the institution.

Wilson's journey from an intellectual powerhouse to a transformative political figure was one marked by challenges, triumphs, and the unyielding pursuit of his vision. Wilson was a man who would go on to become one of America's most consequential presidents, shaping the course of the nation and the world in the turbulent times that lay ahead.

Born in Virginia before the Civil War, Woodrow Wilson came of age in the American South, growing up in Augusta, Georgia, and South Carolina during the Civil War and Reconstruction. As a young man, Wilson left the Deep South for New Jersey, enrolling at Princeton University for his bachelor of arts and then on to the University of Virginia Law School before receiving a doctorate in history and government from Johns Hopkins University.

Wilson graduated from Princeton University with a bachelor's degree in 1879 and Johns Hopkins University with a PhD in 1886. He is the only American president who earned a PhD. His southern childhood and northern education profoundly shaped his politics, embracing a Progressive Era belief in government as a tool for equity while still mainly ignoring segregation.

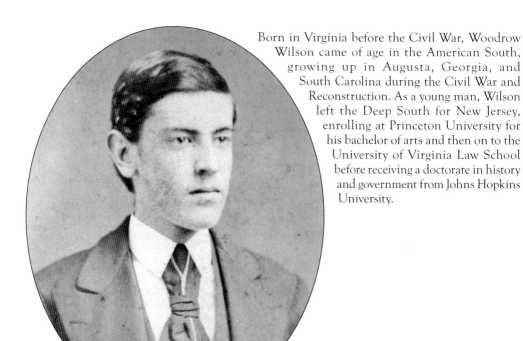

Wilson's father, Joseph Ruggles Wilson (1822–1903), was a prominent Presbyterian minister. His parents were immigrants from Northern Ireland. He defended slavery and set up a Sunday school for slaves. He and his wife supported the Confederacy during the American Civil War and cared for the wounded soldiers at their church.

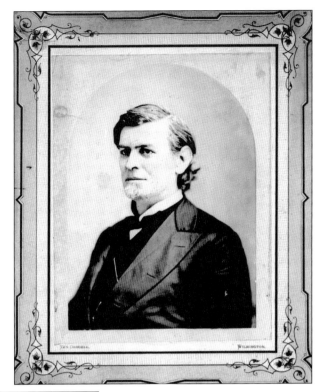

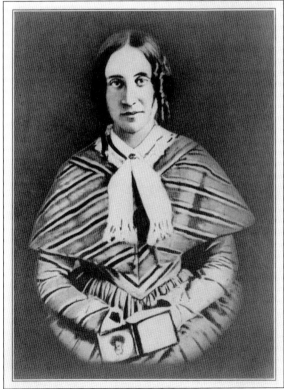

Wilson's mother, Jessie "Janet" (Woodrow) Wilson (1826–1888) was born in Carlisle, England. Wilson, a self-described "mama's boy," remembered his mother fondly for her warm demeanor and maternal nature. She and Joseph had four children: Marion, Annie, Woodrow, and Joseph Jr.

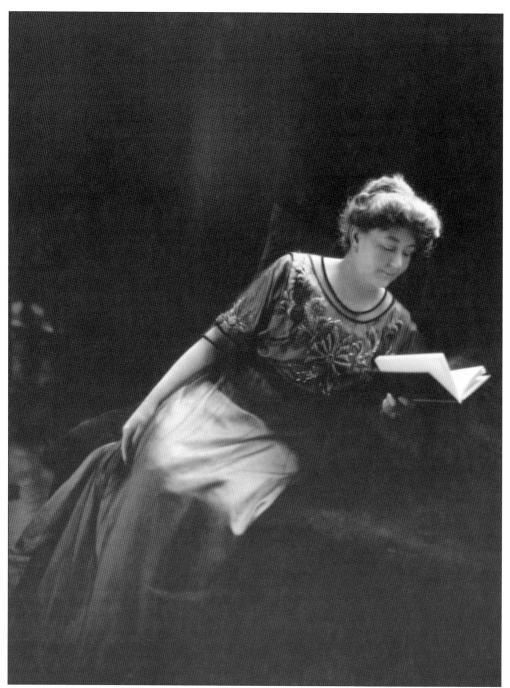

Woodrow Wilson and his first wife, Ellen (Axson) Wilson (1860-1914), married in 1885. He was 28, and she was 25 years old. Ellen was born in Savannah, Georgia, and grew up in Rome, Georgia. Her father was also a Presbyterian minister. She graduated from Rome Female College, studied at the Art Students' League of New York, and was an accomplished artist. Several of her paintings hang in the Woodrow Wilson House museum.

In 1890, Woodrow was appointed to the chair of jurisprudence and political economy at Princeton University. Widely respected as an academic and known for his public speaking skills, he was chosen president of the university in 1902 and moved to the commanding Prospect House on the Princeton campus with Ellen and their three daughters. Here, Ellen planted a rose garden which she would later replicate at the White House.

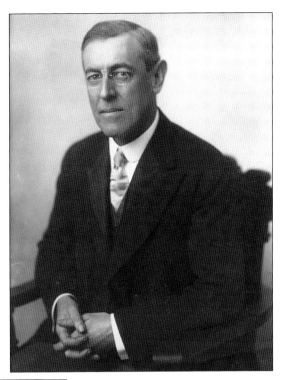

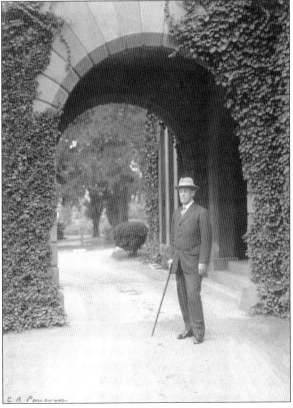

Woodrow Wilson gained recognition for his efforts to reform and expand Princeton. During his tenure, he appointed the first Jewish and Roman Catholic faculty members. He is seen here outside Prospect House at Princeton University.

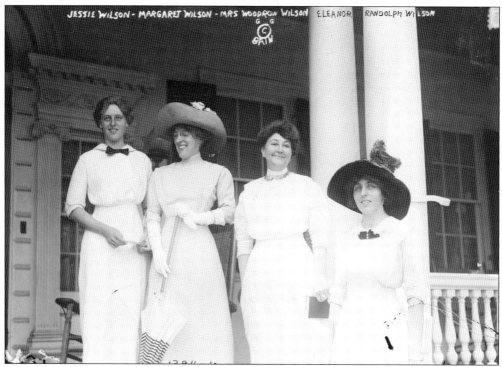

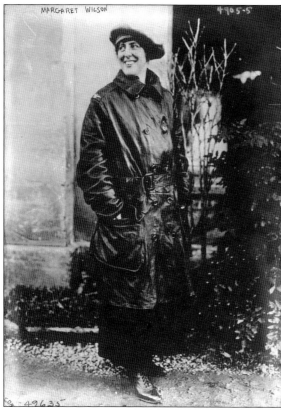

The Wilson daughters were close to both their parents. Seen here, from left to right are Jessie, Margaret, Woodrow's first wife, Ellen, and Eleanor in about 1912. Woodrow and Ellen's three daughters moved to the White House when Wilson became president.

Margaret Woodrow Wilson, the oldest daughter (1886–1944), attended Goucher College (formerly Woman's College of Baltimore City), where she studied music. A singer and a musician, she played for the troops during World War I and raised funds for the Red Cross. The Steinway concert grand piano in the Woodrow Wilson House was a gift to her from her father. Margaret died in an ashram in Pondicherry, India, in 1944.

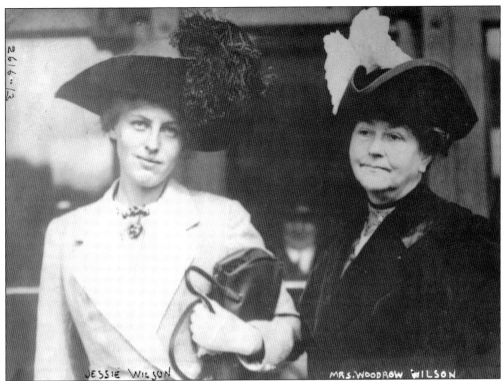

Jessie Woodrow (Wilson) Sayre (1887–1933) graduated from Goucher College summa cum laude and Phi Beta Kappa. She was a political activist and suffragist and worked to promote the creation of her father's vision of the League of Nations. She campaigned for Al Smith in 1928 and was a friend of Franklin Roosevelt. She is seen here with her mother, Ellen, whom she closely resembled both physically and intellectually.

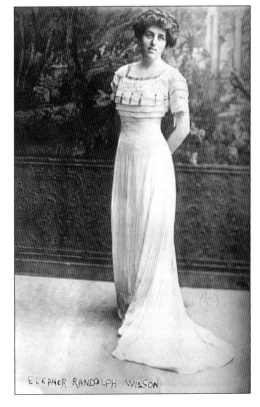

Eleanor "Nell" Randolph (Wilson) McAdoo (1889–1967) graduated from St. Mary's School in Raleigh, North Carolina, and was a writer and the author of *The Woodrow Wilsons*, which describes her childhood and the close relationship all the daughters had with their parents. She later was an advisor to the Zanuck film *Wilson*.

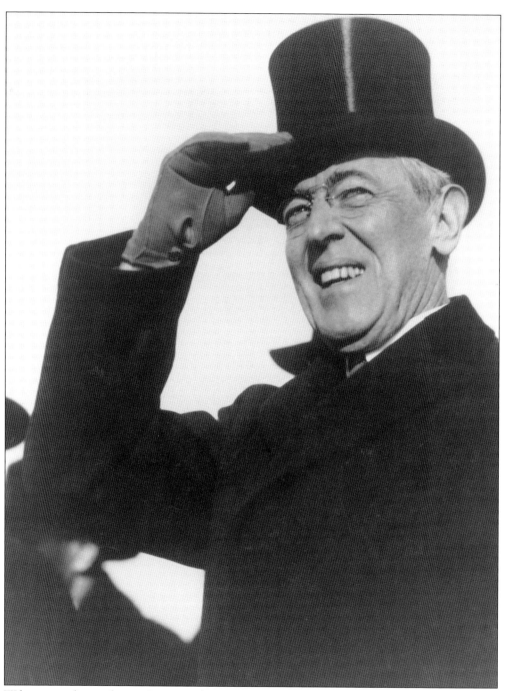

Wilson was a dapper dresser. Prior to politics, though, he looked more professorial than presidential, he began dressing more fashionably when he entered the national stage. The top hat was the fashion of the time; more than any other president, Wilson is remembered for his top hat, as seen in this iconic image.

Two

AN UNPRECEDENTED FIRST LADY

Edith (Bolling) Galt Wilson was a remarkable woman whose influence extended far beyond the traditional role of the First Lady. The second wife of Woodrow Wilson, Edith stood at the side of one of America's most transformative presidents and played an unprecedented role in shaping the course of the nation during a crucial period.

As the longest resident of 2340 S Street, Edith Wilson defined its mission. Her bequest of the home to the National Trust for Historic Preservation stipulated that the Kalorama neighborhood house stand as a memorial to her husband. It was that directive that has shaped the stories told and the ones we will continue to tell in the years to come.

Edith Bolling was born to an old established family in Wytheville, Virginia, on October 15, 1872, the seventh of eleven children. A direct descendant of the first European settlers who arrived on the Powhatan land of Tsenacomoco, which the English settlers named "Virginia," Edith is also a direct descendant of the Powhatan chief's daughter Pocahontas, whose portrait hangs in Edith's bedroom at the museum.

At the age of 24, Edith married the Washington, DC, jeweler, Norman Galt who died in 1908. Uncharacteristically for a woman of that era, Edith maintained ownership of her husband's business and established her place among the capital's social circles. In early 1915, less than a year after Woodrow Wilson's first wife, Ellen (Axson) Wilson, died, Edith's connections led her to meet the president. The pair quickly fell in love and were married in a small private ceremony on December 18, 1915, in her home in Washington.

Edith's journey from a private life to the most public role in America was not without its challenges. Her personality, intelligence, and strong-willed nature would prove instrumental in navigating the intricacies of Washington politics. She redefined the role of First Lady as she wielded unprecedented influence that impacted the nation's governance. Her story continues to be an inspiration for those who seek to understand the power and potential of the First Lady's role.

Edith Bolling was born in Wytheville, Virginia, a small town at the foot of the Blue Ridge Mountains. She is seen here in 1873 with Matilda Havens Stepteau, born in Bedford, County, Virginia, in 1849. Matilda was in service to the Bollings and remained part of Edith's life beyond Wytheville. Matilda was one of the few guests invited to Edith's wedding to President Wilson 43 years later.

Although one of Virginia's oldest families, the Bollings lost much of their wealth during the Civil War. After losing their plantation in Campbell County, Edith's father practiced law to provide for his wife and children. Edith is number seven of eleven children, only nine of whom survived infancy. Their house in Wytheville was filled with relatives, including an invalid grandmother who homeschooled Edith.

20

Through her patrilineal line, Edith Bolling was descended from Matoaka, better known as Pocahontas, a fact she was enormously proud of throughout her life. At 15, Edith began attending Martha Washington College to study music, but she left after one semester. Despite their social prominence and reverence for learning, the Bollings had to conserve funds to educate Edith's younger brothers.

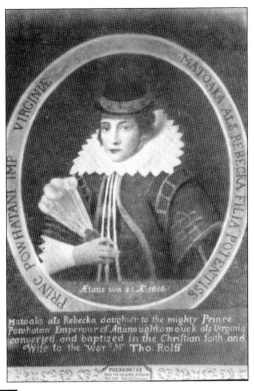

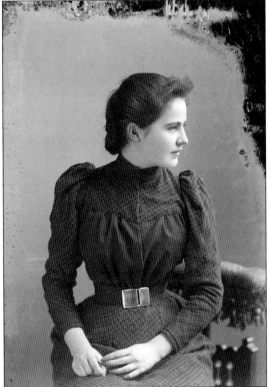

By her teenage years, Edith Bolling had grown into a tall, quick-witted, attractive young woman. The young girl who had foraged for wild mushrooms with her siblings in the fields around their sleepy hometown recalled a happy, extended childhood, shielded from much of life's cruelty by doting and devoted parents.

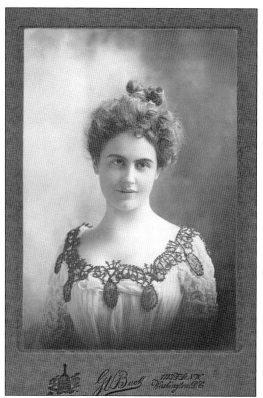

Many young women of Edith Bolling's time were deprived of educational opportunities. Families with limited resources gave preference to educating their sons, who would one day require skills to provide for their own families. Between Martha Washington College in Abingdon and the Powell School in Richmond, Edith had only two years of "higher" education. When she finished school, Edith came to Washington to visit her sister Gertrude.

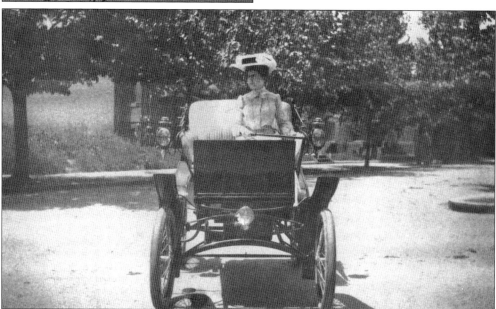

In 1896, at 23, she married Norman Galt, of the distinguished Galt family jewelers in Washington, DC. Edith met Norman through her sister Gertrude's husband, Hunter Galt, Norman's cousin and business partner. Edith Bolling was one of the first women in Washington, DC, to possess a driver's license. She was frequently seen darting through the city in her Columbia Elberon Victoria Mark XXXI.

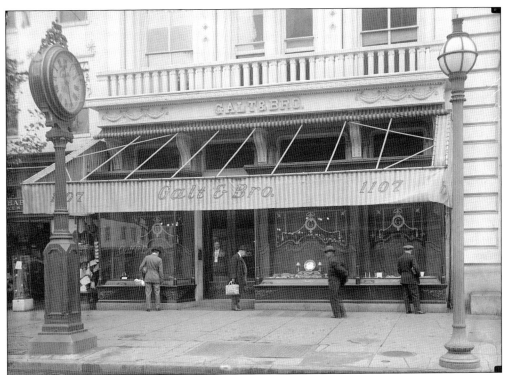

Norman Galt's skilled operation of his family's business, Galt & Bro. on Pennsylvania Avenue, provided a comfortable upper-middle-class life in Washington's Dupont Circle neighborhood. A son resulted from the marriage in 1903 but died in infancy; Edith was unable to bear any other children. The couple enjoyed restaurants, trips abroad, and nights at the theatre. Edith had a notorious weakness for couture clothing.

Norman Galt died unexpectedly in 1908 after an illness, leaving Edith, 35, as his heir. Instead of liquidating Galt & Bro., Edith hired a manager and devoted herself to learning the business, meanwhile living simply in order to pay off outstanding debts. Years later, Edith's widowed sister Gertrude, pictured here with Edith (standing) and their Galt husbands, would live with Edith at 2340 S Street.

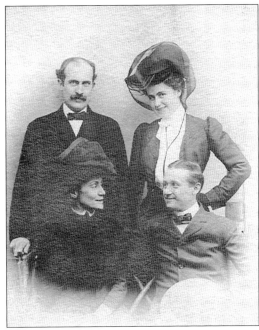

Mutual acquaintances in Washington society introduced Edith to Woodrow Wilson in the spring of 1915. Edith fell deeply in love with the president, although the obligations associated with being First Lady made her hesitant to accept Wilson's marriage proposal. Love eventually won out, and the two were married in December in a quiet ceremony in the drawing room of Edith's small house at 1308 Twentieth Street near Dupont Circle.

After Woodrow Wilson's death, Edith never remarried, stating that there was no greater title than "Mrs. Woodrow Wilson." Edith was only married to Woodrow for eight years of her long, eventful life. The deep impression that those fleeting years left upon Edith is a testament to the powerful love between these two incredibly complex personalities.

Three

Progressive-Era Politics

While governor of New Jersey, Woodrow Wilson won the Democratic presidential nomination in 1912 on a "Progressive" platform. In an unexpected turn of events, Theodore Roosevelt entered the presidential race, splitting the Republican vote. Wilson defeated Roosevelt and incumbent Republican William Howard Taft, making Wilson the first Southerner elected to the presidency since before the Civil War.

Wilson emerged as a transformative figure, his ideas and leadership epitomizing the Progressive Era. The era was a response to the rapid expansion and overcrowding of cities, inadequate housing, unregulated labor, poor public health, farmer indebtedness, and sharecropping—especially for Southerners, Black and White—child labor, and the emergence of a wealth gap in which one percent of Americans owned ninety percent of the nation's wealth.

Progressives sought solutions in the form of child labor laws, women's suffrage, unionization, public health services, African American civil rights, economic regulation, and taxes, as well as immigration restriction, segregation, and the prohibition of alcohol.

Wilson claimed his place within the Progressive movement with his economic reform package, "the New Freedom." This agenda included lower tariffs, banking and labor reforms, and the introduction of an income tax. Wilson also expanded the executive branch with the creation of the Federal Reserve, the Federal Trade Commission, and the Internal Revenue Service. His emphasis on efficiency and bureaucracy fit him squarely within the Progressive movement. During Wilson's terms, Congress passed two constitutional amendments: prohibition (18th); and women's suffrage (19th)—Wilson opposed prohibition and supported suffrage.

The appointment of his friend Louis Brandeis to the Supreme Court as the first Jewish American to sit on the nation's highest court solidified Wilson's Progressive legacy. Brandeis was a staunch proponent of the right to free speech and the right to privacy while he supported the regulation of business and anti-monopoly legislation championed by Wilson's economic plan.

An early adaptor of modern technology, Wilson opened the Panama Canal, started airmail service, endorsed the creation of an interstate highway system, appeared in one of the first filmed campaign advertisements, used a microphone for the amplification of his voice, and witnessed the birth of radio.

In 1910, Princeton's president waded into the waters of politics and entered New Jersey's gubernatorial election. He won the election on an energized platform centered around the rejection of trusts and corruption as much as the puppeteering of party bosses. After his election victory, leaders of the Democratic Party were surprised and disappointed to learn that Wilson meant these promises. Here, at the governor's summer residence in Sea Girt, New Jersey, Woodrow Wilson planned his political career.

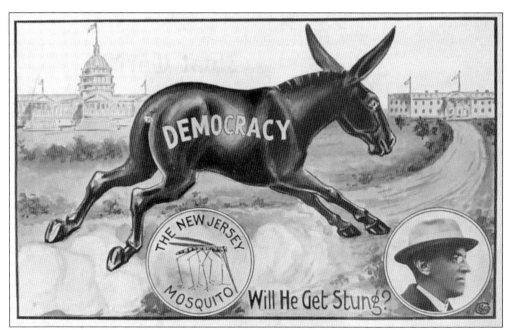

The sting of Woodrow Wilson's political vigor was an allusion to a tamer donkey-themed postcard that was disseminated during the campaign of William Jennings Bryan in the previous presidential election. American voters hungry for change installed Democratic majorities in both chambers of Congress in 1912 for the first time in 20 years. Wilson, many hoped, was the sting the executive branch needed.

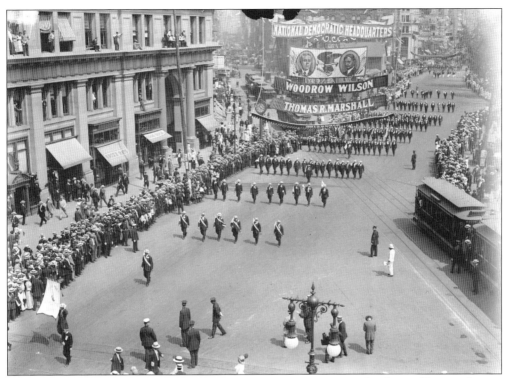

In 1910, Wilson won the gubernatorial nomination as a Democrat in New Jersey. He served a year and a half as governor before receiving the Democratic nomination for president in 1912. That same year, in a parade in New York City celebrating the 5th Olympic Games, held in Stockholm, Sweden, the likenesses of Wilson and his running mate Thomas Marshall dominated a banner advertising the National Democratic Headquarters.

Wilson's running mate was the Democratic governor of Indiana, Thomas R. Marshall. Marshall once recounted a story of a man with two sons. One went to sea and drowned; the other was elected vice president. He was fond of saying, "Neither son was heard from again." Marshall never developed a close relationship with Wilson.

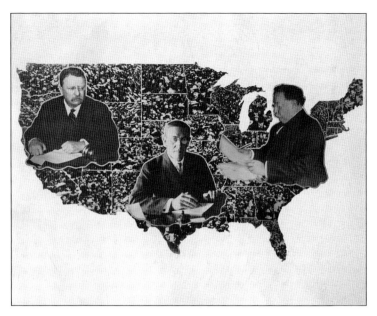

Woodrow Wilson catapulted to prominence in national politics, winning the Democratic nomination in 1912 for president on a Progressive platform. He defeated Theodore Roosevelt (left), the Progressive Party candidate, and Republican William Howard Taft (right), making Wilson the first Southerner elected to the presidency since the Civil War, more than half a century before.

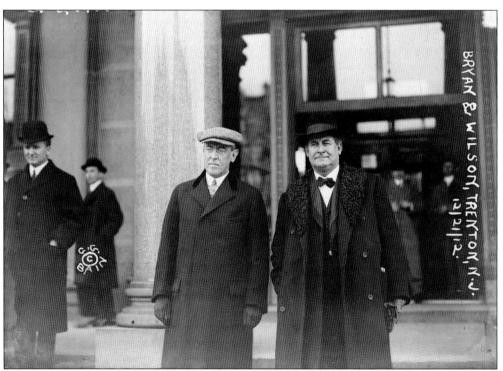

Woodrow Wilson (left) and William Jennings Bryan are seen in Trenton, New Jersey, on December 21, 1912. Bryan was appointed as secretary of state and served from 1913 to 1915. He advocated for Wilson's foreign policy agenda, which included a focus on diplomacy and the avoidance of conflict. He resigned in 1915 due to differences with Wilson over issues related to the United States' stance on neutrality in World War l.

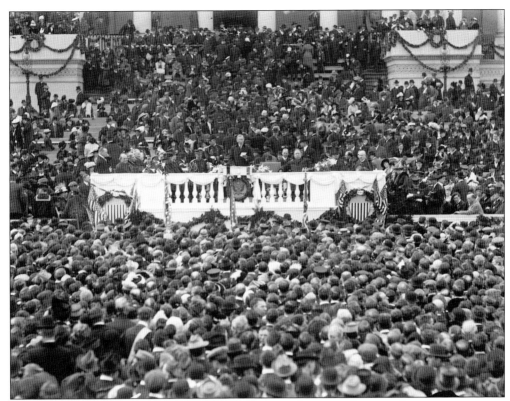

The Industrial Revolution dramatically changed the United States in the span of just two generations. Wilson swept to power on a Progressive platform including banking reform, regulation of monopolies, and workers' rights. On March 4, 1913, Wilson was sworn in as the 28th president of the United States. Despite the three-way race, he carried the largest percentage of electoral votes garnered by any presidential candidate in 40 years.

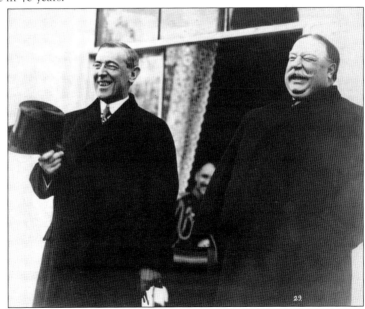

In his first inaugural address, the new president (shown here with William Taft) promised reforms to a nation that had been "stirred by a solemn passion, stirred by the knowledge of wrong, of ideals lost, of government too often debauched and made an instrument of evil."

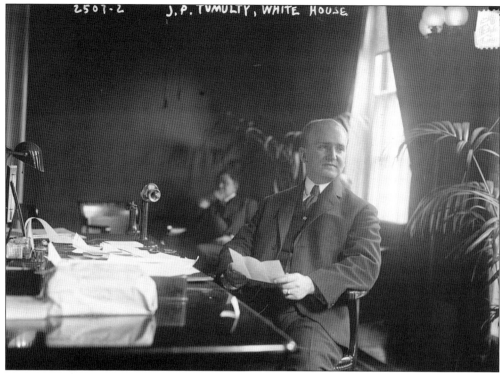

Joseph P. Tumelty, seen here in the White House, was a New Jersey attorney and political advisor who served as the private secretary to Woodrow Wilson during his time in office from 1913 to 1921. Tumelty played a crucial role in managing Wilson's correspondence and communications with various government officials and the public. He was involved in shaping Wilson's policies and acted as a close confidant.

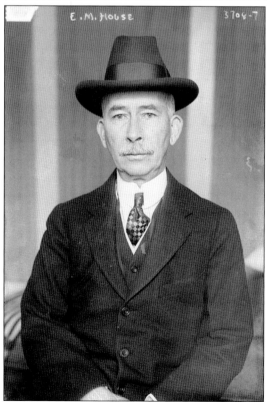

Col. Edward M. House was a key political advisor and diplomat during the presidency of Woodrow Wilson. He played a significant role in conducting United States foreign policy during World War I and the negotiations leading to the Treaty of Versailles.

When Woodrow Wilson delivered his first address to Congress on April 8, 1913, he was the first president in more than a century to deliver the speech in person.

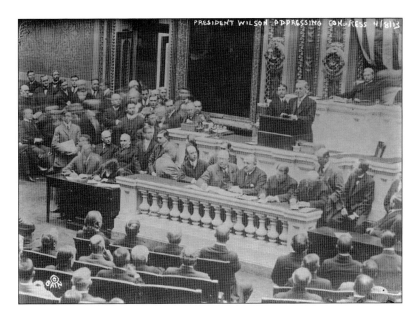

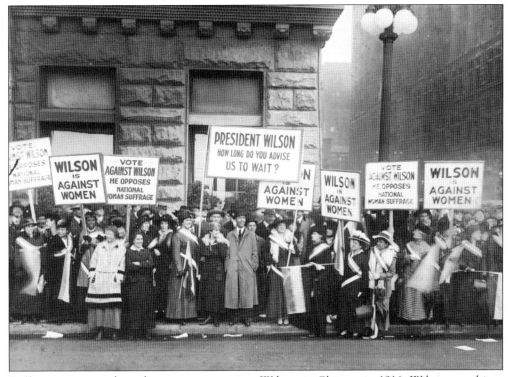

Suffragists are seen here demonstrating against Wilson in Chicago in 1916. Wilson voted in a state-level election in Princeton in October 1915 in support of women's suffrage. He believed that discussions on suffrage should be left to the states. By 1918, Wilson had changed his mind and heartily supported the passage of the 19th Amendment as a means of supporting his broader mission of "helping to make the world safe for democracy."

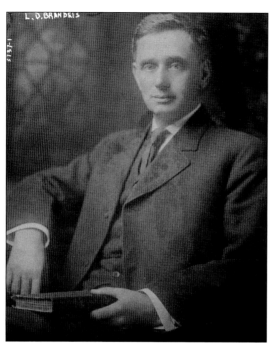

Wilson met Louis Brandeis during the 1912 campaign. The president nominated Brandeis to the Supreme Court in 1916, where he faced a contentious confirmation process from a Republican party threatened by Brandeis's ideas on workers' rights and regulating monopolies. A nomination process that normally took just one day dragged on for four months. The first Jewish American to serve on the Supreme Court, Brandeis held his seat for 23 years.

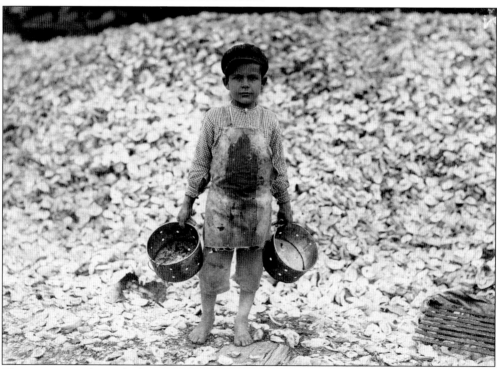

The country was being built upon the shoulders of children. In 1900, one in five children of all ages was working. Manuel, a five-year-old shrimp-picker at Dunbar, Lopez, Dukate Company, in Biloxi, Mississippi, stands before a mountain of shells picked by children who worked year-round. Interviewers at the time said he did not understand or speak a word of English. Labor reform was part of Wilson's platform.

In 1914, President Wilson signed a measure officially establishing the second Sunday in May as Mother's Day. His first wife, Ellen (Axson) Wilson, seen here in 1912, was known for her interest in the arts and her support for various social causes. She advocated for better housing and living conditions in overcrowded and unsanitary urban areas and advocated for the Alley Dwelling Authority to provide better housing for low-income Americans.

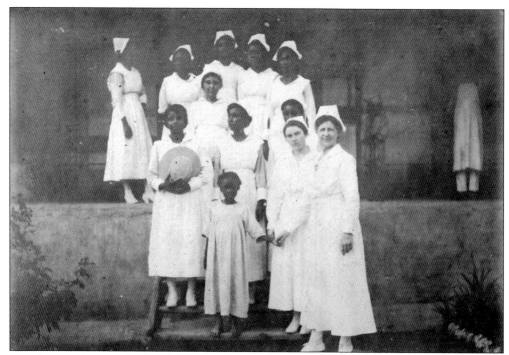

Woodrow Wilson entered office with the United States already deeply involved in Caribbean interests. He sent US Marines into Haiti and the Dominican Republic to restore order and maintain political and economic stability in the Caribbean and he expanded control over Cuba and Panama for American interests. Seen here are Red Cross nurses in Haiti.

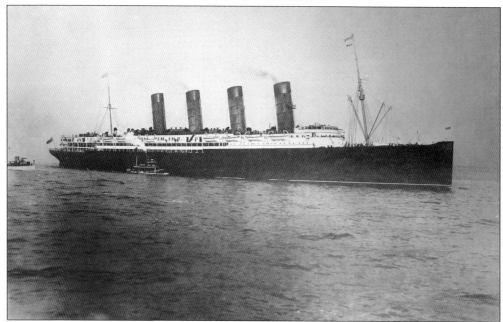

On May 7, 1915, the British passenger liner *Lusitania* was torpedoed and sunk by a German U-boat. *Lusitania* sank in just 18 minutes, claiming 1,198 lives, including 128 Americans. This incident did more than any other to bring the war home to Americans.

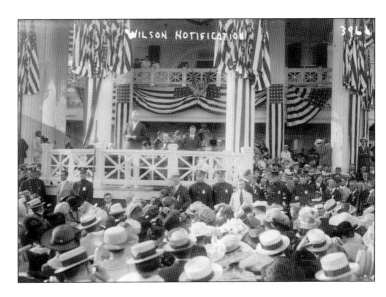

Woodrow Wilson accepted his renomination as the Democratic nominee at Shadow Lawn, the summer White House in New Jersey, in September 1916. Public opinion was deeply divided on whether the United States should become involved in World War I. Wilson's foreign policy was shaped by the position that direct involvement in this war was wrong.

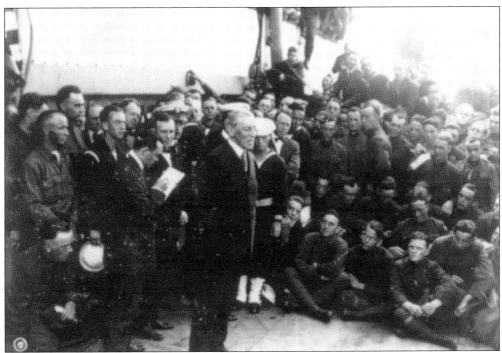

Wilson is seen speaking to sailors aboard a naval vessel. Wilson was a powerful orator with a smooth tenor voice and a confident, relaxed demeanor. Surviving audio recordings and film reels of his speeches reveal a president who understood how to speak to people in a manner that captured their attention.

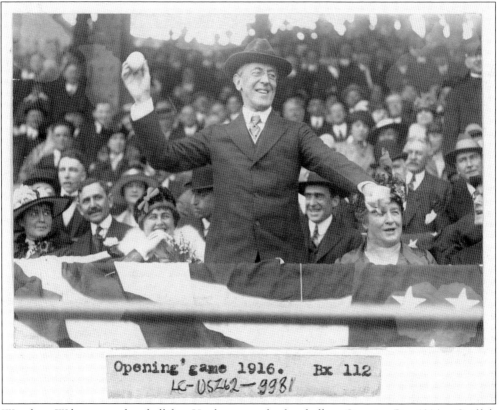

Woodrow Wilson was a baseball fan. He threw out the first ball on Opening Day 1916 at Griffith Stadium in Washington. Edith sits to the left of the president, with a delicate gloved hand concealing her infectious laugh. The First Lady was known to knit while watching baseball games, with her needles later crafting socks for soldiers.

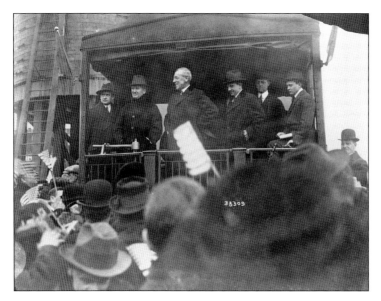

Woodrow Wilson won reelection in 1916 by a narrow margin. Despite his neutrality policies, he was wary of the risks of an Allied defeat. Wilson toured the country to encourage military preparedness. Here, he is shown speaking from the rear of his special train at Waukegan, Illinois, in January 1916.

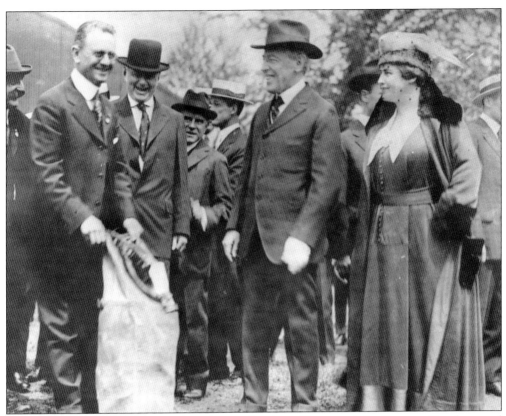

Wilson embraced and encouraged modern technology. He opened the Panama Canal, started airmail service (pictured), endorsed the creation of an interstate highway system, appeared in one of the first filmed campaign advertisements, used a microphone for the amplification of his voice, and witnessed—and participated in—the birth of radio.

Ellen Wilson initiated designing and planting the White House Rose Garden, seen here in 1913, based on the garden she designed while at Princeton. The White House Rose Garden was completed by Edith Wilson. While elements of the White House grounds have changed—often many times over— during the past century, their purpose as the president's entertainment space has remained constant, directly reflecting their policies and priorities.

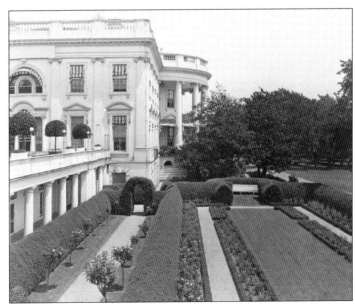

Labor representatives posed on the steps of the White House South Portico. Wilson's administration played a hand in guiding legislation through Congress that resulted in the prohibition of child labor. Wilson also supported and signed into law the Adamson Act, which created an eight-hour workday for railroad workers.

This is another view of the Rose Garden looking west, where Victorian greenhouses had long stood. Ellen Wilson designed the long, privet-lined gravel walk in the bottom right-hand corner—called "the President's Walk"—to give the president a more formal approach from the residential space in the White House to the offices in the West Wing.

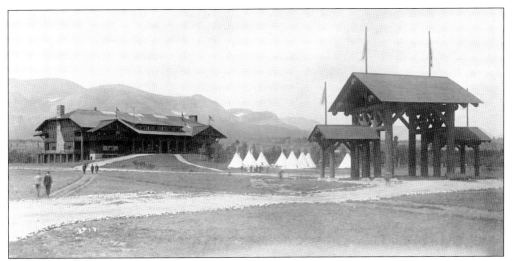

On August 25, 1916, Wilson signed legislation that created the National Park Service. Seen here is the entrance to Glacier National Park in about 1914. Today, the National Park Service comprises 425 areas covering more than 85 million acres in every state, the District of Columbia, American Samoa, Guam, Puerto Rico, and the Virgin Islands.

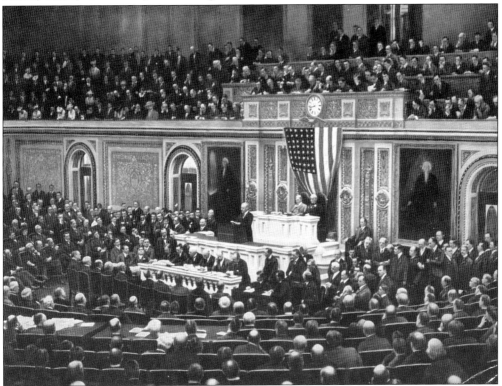

Early in 1917, Woodrow Wilson attempted to negotiate a "peace without victory" that would end the war, to no avail. Renewed U-boat attacks on shipping led to a break in diplomatic relations between Washington and Berlin that left Wilson with few choices. On April 2, 1917, the president asked Congress to declare war on the German Empire. The Senate voted in agreement 82-6 and the House 373-50.

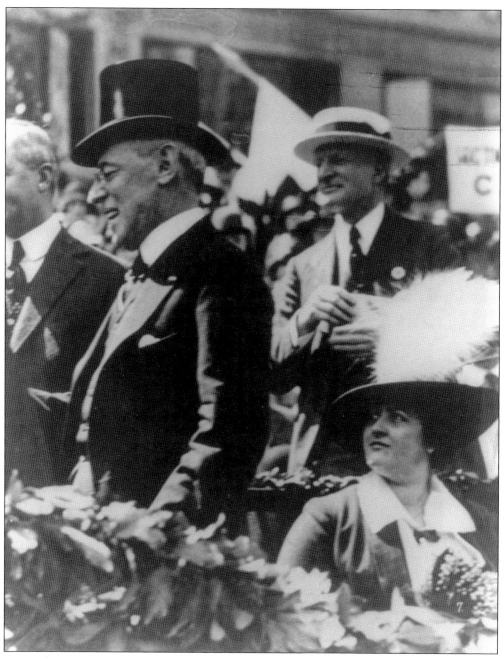

Despite his often controversial policies, Wilson's temperament was particularly well-suited to the presidency: his remarkable thoughtfulness, confidence, and ability to mediate were invaluable leadership qualities during this transformative age. Seen here, Wilson was in his prime. Standing at five feet and eleven inches, Wilson in his top hat cut a commanding figure.

Four

THREE WEDDINGS AND A FUNERAL

Wilson's first term as president bore witness to a series of profoundly personal events that resonated deeply with the American public. In a poignant chapter of his presidency, a trio of weddings and a funeral unfolded against the backdrop of a nation grappling with the complexities of World War I and the progressive reforms that Wilson championed.

In November 1913, middle daughter Jessie exchanged vows with Francis Sayre, and in the spring of 1914, youngest daughter Nell wed William Gibbs McAdoo, Wilson's secretary of the treasury. These events captured the nation's attention. The joyous celebrations became a symbol of resilience and optimism for a family navigating the pressures of the presidency.

Regrettably, mere months later, the Wilson family faced profound loss. Ellen (Axson) Wilson, Woodrow's first wife and the mother of their three daughters, succumbed to kidney disease in August 1914. Her passing cast a somber shadow over the White House. Wilson, grieving deeply, would soon grapple with the complexities of presiding over the nation as a widower, with his eldest daughter Margaret, followed by his cousin Helen Bones, stepping into the role of "social hostess."

However, it was the third wedding that would etch the most enduring symbol of Wilson's initial administration. In December 1915, just over a year after the loss of Ellen Wilson, Woodrow Wilson married Edith (Bolling) Galt, a widow and confidante who had become an indispensable source of support during his time of mourning. This marriage marked a personal turning point for Wilson and strengthened him to face the challenging work ahead.

The interplay of personal and political events during Woodrow Wilson's first administration—a period distinguished by joyous celebrations, profound bereavement, and a transformative marriage—provides a unique lens through which to comprehend the man behind the presidency and the intricate challenges of leadership during one of the most demanding eras in American history.

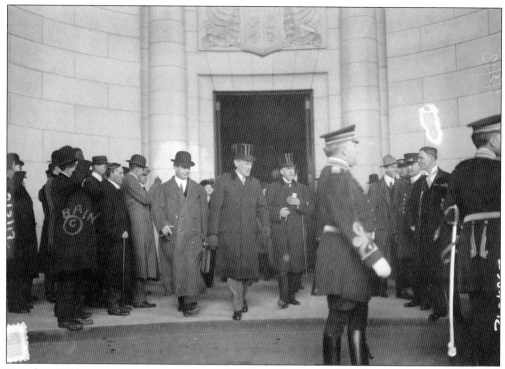

Woodrow Wilson is seen here leaving the new Union Station in Washington, DC, as he arrived for his inauguration as president on March 4, 1913. The Wilson family experienced a series of significant events in a relatively brief period during Woodrow Wilson's first term as president, including three weddings—and a funeral.

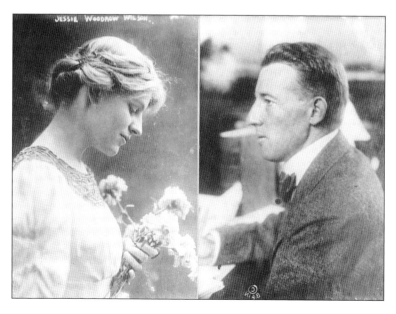

Daughter Jessie Wilson married Francis Bowes Sayre in November 1913 in the East Room of the White House. Flocks of spectators lined up outside the White House to catch a glimpse of the Wilson-Sayre wedding party. The couple eventually had three children.

In May 1914, daughter Eleanor "Nell" Wilson married William Gibbs McAdoo Jr., secretary of the treasury. McAdoo was a widower with five children who was Nell's senior by 26 years. Nell and McAdoo had two daughters. Nell later divorced McAdoo on the grounds of incompatibility.

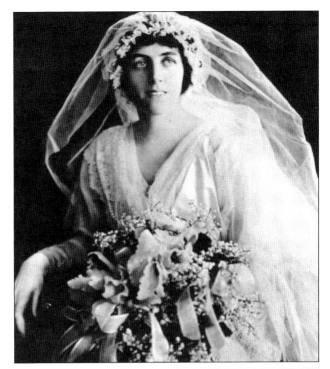

Ellen Wilson died from Bright's Disease on August 6, 1914. Woodrow Wilson was devastated by this loss, and in the void left by Ellen's absence, he fell into a deep depression. After Ellen's death, daughter Margaret served her father as the White House social hostess, a title that later became the First Lady.

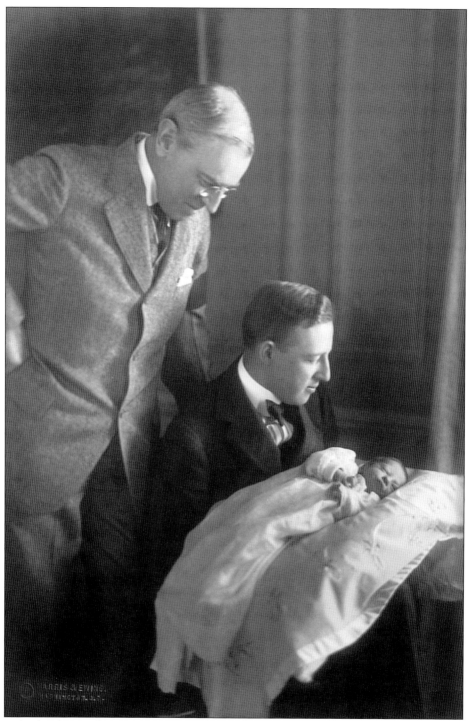

Jessie (Wilson) Sayre lived in Massachusetts; however, her son Francis B. Sayre Jr. was born in the White House in January 1915. Francis Sayre would be the first presidential grandchild born at the White House. He later grew up to be the Very Reverend Francis B. Sayre Jr., dean of the Washington National Cathedral, where his grandfather is buried.

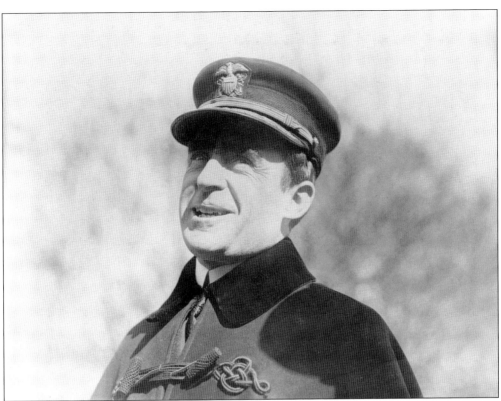

After having met in 1913, Dr. Cary T. Grayson and Woodrow Wilson developed a close friendship that led to Wilson's appointment of Grayson as his physician and as a rear admiral in 1916. A fellow Southerner from Virginia, Grayson played a role in introducing Woodrow and Edith in 1915.

Helen Bones, Woodrow's cousin, served as First Lady after daughter Margaret. In March 1915, Helen introduced Edith to the president, sparking an instant attraction. Any attempt at a discreet courtship was in vain. Despite the scrutiny, Edith refused to break off the engagement, although out of respect for the former First Lady, she insisted on waiting to marry until after the year of mourning had passed.

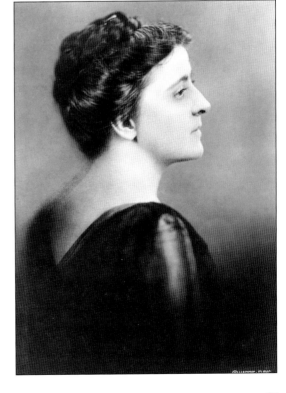

human heart could conceive. I dare not admit how much I miss you, how desperately I long for you — I could not trust myself — but I cannot be unhappy, now: you have rendered it impossible!

Thank you, my Precious, for your sketch of the way you spend your days with the Roses. It interests me very much. But it is evident that you give much more than you get, and your apparent enjoyment of it is only an additional proof of the quality of your friendship. I am glad they are going to bring you down to Ocean City, — glad and sorry; glad because they love you and will take good care of you, — sorry because that is the way

— 5 —

realize what pleasure, what delight, you give to every faculty of appreciation I have. You have faults, of course, — though I cannot for the life of me remember what they are, — but I do not "forgive" them: I love you so that I do not see them, — and I love you for cause, because you satisfy everything that is in me and call out all that is best in me. I could not love or admire a blue-stocking or endure a woman politician! So, please, Ma'am, don't try to alter yourself! It's you I love and admire and enjoy. It's you who completes me with what she gives of tender love and instant comprehension and frank counsel and a companionship that fills all the needs of my thoughts and my af-

August 12 - 1915
11 P.M.

My precious One:
I have come to looking forward to this time with you every night. When the rest of the household is asleep, as the happiest part of the day except when the Postman brings me your part of our blessed talks, and I sit by my window and read those dear pages on which the hand I love has so recently rested — and which brings you and your vital, stimulating mind in direct touch with mine.
I am in bed — and have just finished reading over again your last letter from Harlakenden written "Tuesday evening" and
(over)

Woodrow wrote letters to Edith daily, sometimes twice daily. He shared his day, his thoughts, and his admiration and love for her. These letters, of which there are thousands, portray a very human side to this world leader. He is deeply passionate, profoundly romantic, and uniquely human. In this letter, Wilson writes, "I dare not admit how much I miss you, how desperately I long for you."

Edith's letters to Woodrow were equally chatty, tender, and dreamy. Their correspondence was intimate and personal and demonstrated an extraordinarily strong and deep appreciation for one another and a connectedness that neither one expected, but greatly valued. Here, Edith explains that, aside from when she writes her responses to Woodrow's letters, the happiest part of her day is "when the Postman brings me your post of ever blessed talks."

Much of Woodrow and Edith's relationship evolved within the walls of Edith's narrow row house at 1308 Twentieth Street NW. Here the president was a frequent dinner guest, and a private phone line was installed that connected directly with the White House. The presidential couple were married in the little house's drawing room on December 18, 1915, before setting off for their honeymoon in Hot Springs, Virginia.

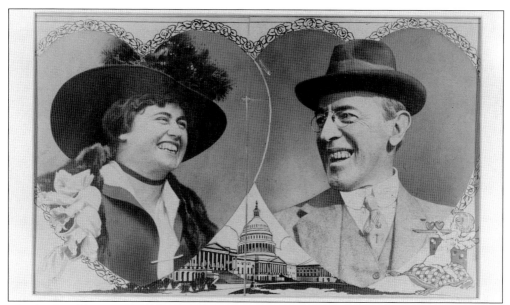

The third wedding of the Wilson administration attracted even more attention. Throughout her marriage to Woodrow Wilson, Edith became the most politically informed First Lady up until that time, attending meetings with the president and advising him on matters of state. It would not be long before this political acumen proved more useful than anyone expected.

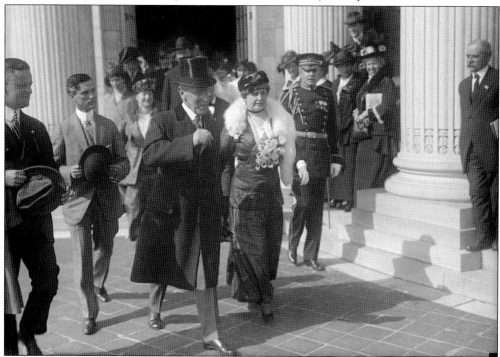

Edith was one of the earliest First Ladies who was frequently seen at the president's side in public and the first First Lady to travel abroad in an official capacity during her term. The support she offered Wilson—both personally as his wife and officially as his First Lady—was invaluable. Edith was the first curator of the Wilson House, keeping it preserved for future generations.

Five

WILSON AND RACE

As the Democratic nominee in 1912, Woodrow Wilson had garnered the cautious support of many among the nation's influential and politically diverse African American leadership. His New Freedom platform promising fairness and equality caught the attention of prominent African American activists including W.E.B. Du Bois, a founder of the NAACP (National Association for the Advancement of Colored People) and publisher of the *Crisis* magazine, and William Monroe Trotter, a prominent and vocal activist and publisher of the civil rights newspaper the *Guardian*.

Before long, however, Wilson's policies dashed the hopes of Du Bois, Trotter, and many other African Americans who had broken away from the Republican Party—or in Du Bois's case, the Socialist Party—to vote for the "progressive" Democrat.

As the first Southerner to ascend to the presidency since before the Civil War, Wilson brought with him a sympathy for segregation and the "Lost Cause" narrative. With segregation laws becoming more entrenched across the South—and segregation in northern states bolstered by redlining—Wilson gave his southern-born cabinet members permission to attempt to segregate their departments.

Wilson sometimes couched his embrace of segregation as part of his Progressive commitment to efficiency, arguing that segregation reduced friction among federal workers and increased productivity. By contrast, in 1917 Wilson vetoed an immigration law that established the Asiatic barred zone and a literacy test for entry, but his veto was overridden.

Ultimately, Wilson's failure to address Jim Crow disenfranchisement, his decision to screen *Birth of a Nation* at the White House in 1915, and his administration's efforts to resegregate the federal government, together helped to further cement the unfortunate systemic racial injustices that defined American life in the 20th century.

As the Democratic nominee in 1912, Woodrow Wilson initially garnered cautious support from many influential and politically diverse African American leaders, including activist W.E.B. Du Bois. However, Wilson gave department heads permission to resegregate the federal workforce, which restricted opportunities for skilled African Americans in the Civil Service.

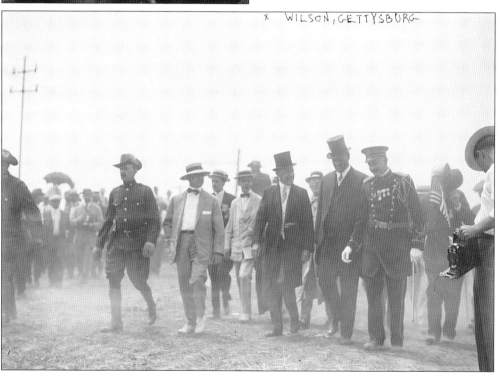

In observance of the 50th anniversary of the Battle of Gettysburg, Pennsylvania hosted a "Great Reunion" of some 54,000 Union and Confederate veterans from across the United States in the summer of 1913. By this point in American history, the anger and tension following the Civil War had softened, transforming into a remembrance focused on restored national unity. Wilson attended briefly and delivered an address as part of the reunion's program.

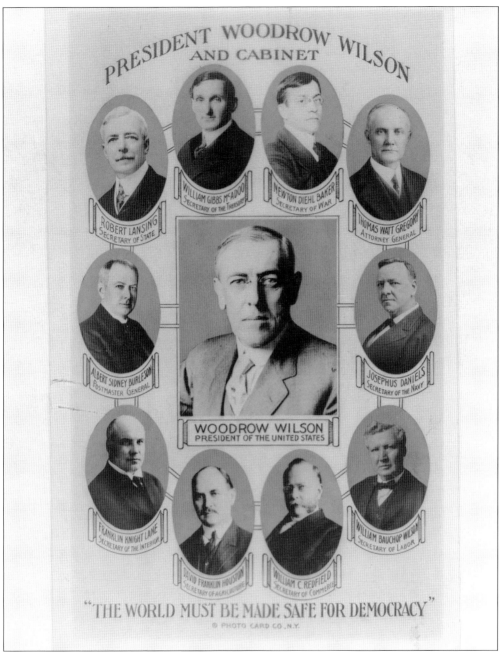

Wilson's cabinet pushed him to initiate policies that influenced the administration's approach to racial issues. Wilson's cabinet choices also reflected his commitment to progressive reforms and his support of the federal government's role in addressing social and economic issues, although that vision did not apply equally to everyone.

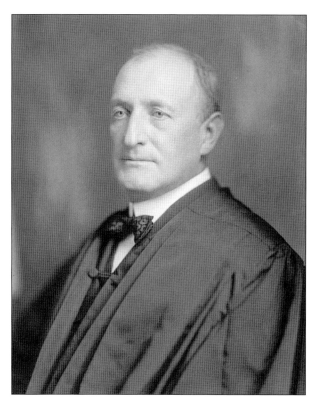

James Clark McReynolds was nominated by Wilson and confirmed by the Senate as an Associate Justice of the Supreme Court. McReynolds frequently disagreed with progressive policies and was openly racist and discriminatory during his 27 years on the Supreme Court. His offensive comments and actions toward fellow justices are often cited as examples of divisions in the court.

Justice Louis Dembitz Brandeis was another associate justice confirmed to the Supreme Court during Wilson's administration. The first Jewish American to serve on the Supreme Court, Brandeis is known for his progressive and socially conscious approach to the law. He made significant contributions to constitutional law, particularly in the areas of free speech, privacy, and individual liberties. Brandeis's eloquent opinions and dissents have left a lasting impact on American jurisprudence.

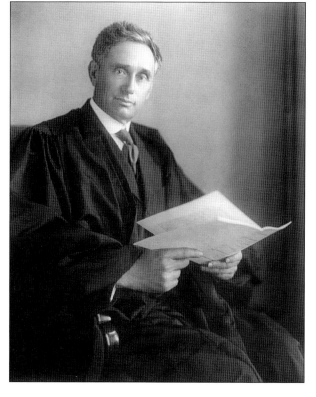

In February 1915, Wilson hosted a screening at the White House of the new film, D.W. Griffith's *Birth of a Nation*. The film offered a bizarre and biased recounting of the Reconstruction Era depicting African Americans as aggressors and glorifying the Ku Klux Klan as righteous Southern heroes. Deeply controversial even then, it is often credited with sparking the resurgence of the Klan after World War I.

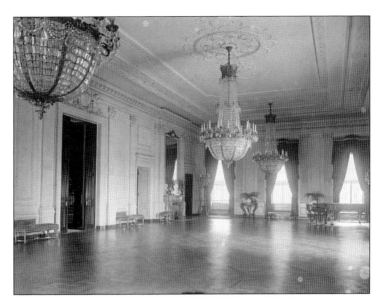

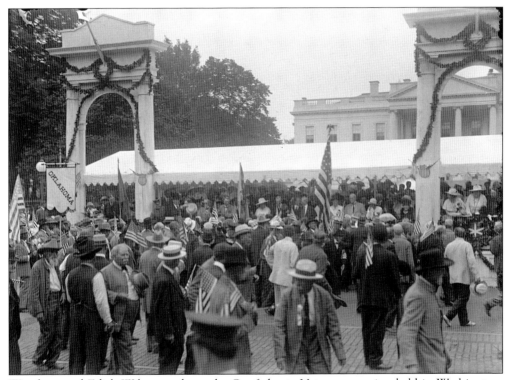

Woodrow and Edith Wilson spoke at the Confederate Veterans reunion held in Washington, DC, in April 1917. Woodrow's vision of American democracy—and how that vision varied across race and class—is symbolized in this photograph, where Wilson is between the grey coats of the Confederacy before him and the White House behind him.

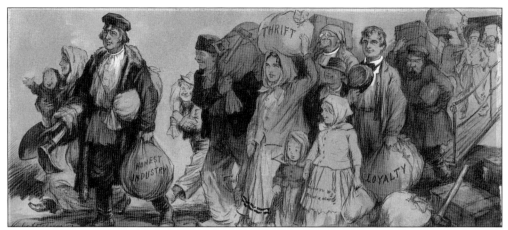

A pair of drawings show the contrast between smiling immigrants arriving from Western Europe labeled with "honest industry," "thrift," and "loyalty" and scowling, slinking immigrants arriving from Eastern Europe labeled with "Bolshevikism," "crazy theories," "anarchy," and "freak ideas."

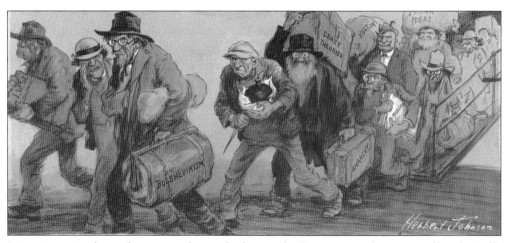

Pejorative attitudes and mistrust also applied toward ethnic groups that were still technically Caucasian but culturally different from mainstream white America.

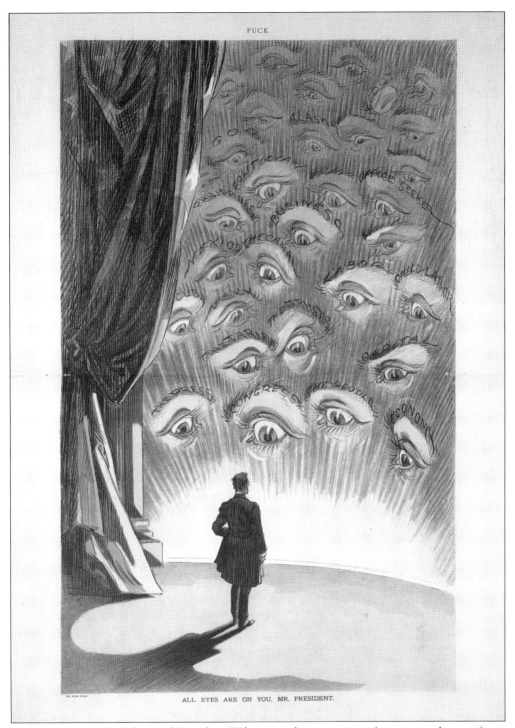

Puck magazine in 1913 depicted President Wilson standing on a stage facing an audience of eyes in this illustration labeled "The Press, Congress, The People, Economy, The Tariff, Capital, The Trusts, Cuba, Navy, Labor, Child Labor, Mexico, The Canal, Philippines, Business, Politician, G.O.P., Office Seeker, Alaska, [and] Teddy."

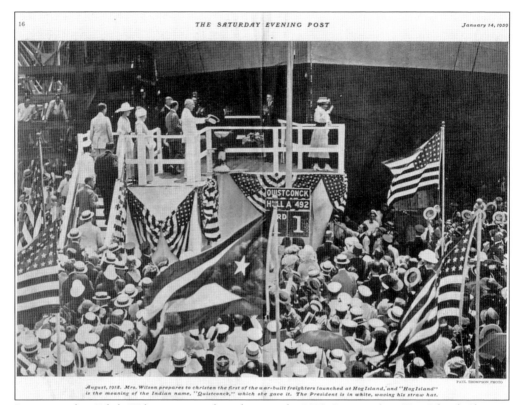

In a news clip, Edith Wilson prepared to christen the USS *Quistconck* at Hog Island. She was tasked with naming a hundred ships during World War I and spent many hours delving deeply into books from the Library of Congress to find ideas for vessel names. Many, like *Quistconck*, reflected America's rich Native American culture.

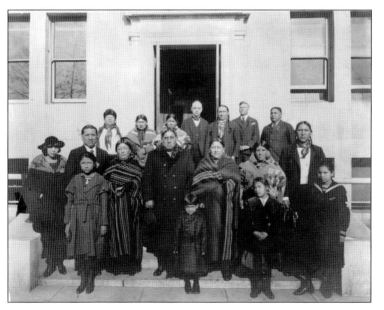

A group of 15 Osage Indians, including Franklin Revard, Chief Bacon Rind, and his wife, posed on steps, in Washington, DC. Edith Wilson herself was a descendant of the Native American princess Pocahontas, and although she was immensely proud of her heritage, she emphasized the "royal" aspect of her Native American lineage much more than its broader cultural significance.

More than 700,000 African American men registered for military service during World War I. However, they suffered indignities including segregated training camps, relegation to support duties rather than combat roles, and a complete ban from the Marines.

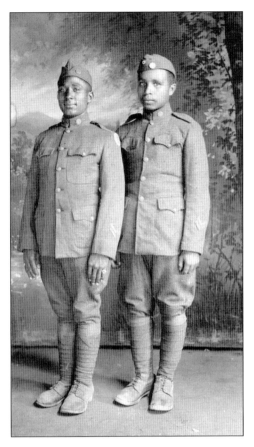

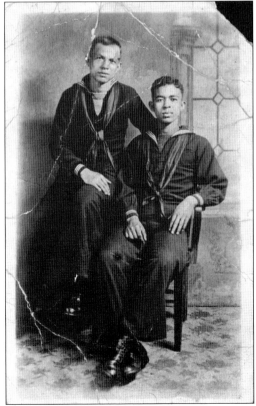

African American enlistments were also completely banned from the Navy from 1919 through 1932. The only African American sailors were those who joined before the 1919 ban and were allowed to stay on until retirement. African Americans once again were allowed to serve onboard US Navy ships in 1932, but only as stewards and mess attendants. The Navy was not fully desegregated until 1946.

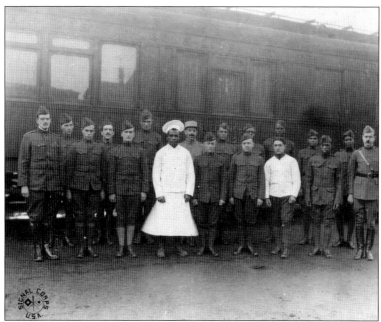

Woodrow Wilson's acquiescence in continuing to segregate the armed forces played out differently from one agency and military branch to the next. The personnel of General Pershing's train, seen here in France in 1918, illustrates a team of mixed races. The Army allowed African American men to serve in their own units.

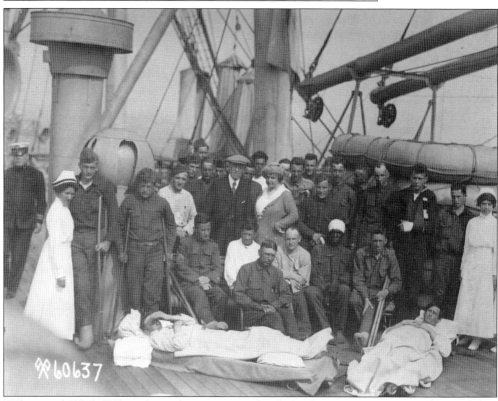

Wilson and Edith Wilson (center) are seen on the deck of a troop transport or hospital ship carrying wounded soldiers. Resegregation extended beyond the battlefield and into medical care. Even African American nurses were segregated from white nurses and were only allowed to treat African American soldiers or German prisoners of war.

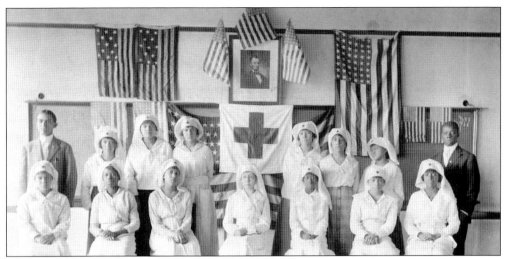

The War Department recruited 21,000 nurses to serve during World War I, about 10,000 of whom served overseas and aboard hospital ships. Seen here, a portrait of 13 unidentified African American women nurses and two unidentified African American men in front of a Red Cross flag, American flags, and portrait of Abraham Lincoln, seen here in Princeton, Indiana, in 1917-1919.

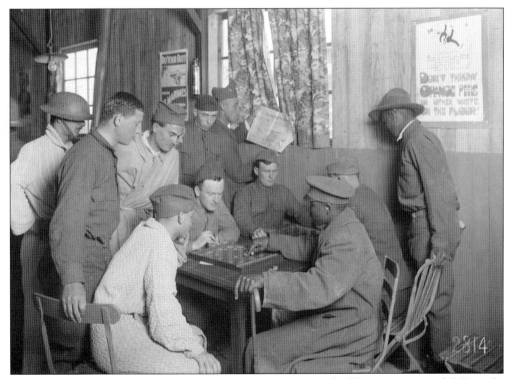

American soldiers in France, where segregation was not enforced off base, were treated differently. Seen here, convalescent American soldiers of both races play checkers in an American Red Cross pavilion in Chaumont, France.

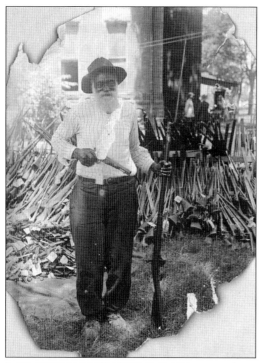

The summer of 1919, the first after the end of World War I, was known as the Red Summer. Race riots rocked cities and towns across the country, fueled by African American resentment of unfair treatment in the military, and white supremacist attacks in response. Seen here, Daniel Hoskins with guns deposited at Gregg County Courthouse, Longview, Texas, following a race riot there in July 1919.

During his presidency, Woodrow Wilson made three significant appointments to the US Supreme Court: McReynolds, in 1914; Brandeis, in 1916; and John Hessin Clarke, in 1916. President Harding appointed former president William Howard Taft as chief justice of the Supreme Court in 1921. Seen here is the court in 1921; they are, from left to right, William R. Day, Louis B. Brandeis, Joseph McKenna, Manlon Pitney, William Taft, James Clark McReynolds, Oliver Wendell Holmes, John Hessin Clarke, and Willis Van Devanter.

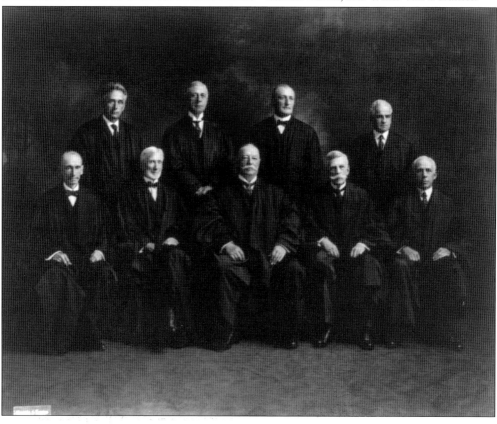

Six

WORLD WAR I, PARIS, AND WILSON'S VISION FOR PEACE

At the Paris Peace Conference in 1919, Woodrow Wilson moved the seat of the presidency to Paris for six months while he played the leading role in drawing up terms of peace including his design for a League of Nations. Wilson took direct personal control of American foreign policy, which he believed was constitutionally mandated. He personally attended meetings and negotiations and penned his approval of the terms of peace and the Covenant of the League of Nations. But Wilson's biggest fight was yet to come.

Back in the United States, the Senate had reservations over the League, reservations that still echo today, about the United States losing sovereignty and becoming the "policeman of the globe." The Senate failed to consent to the treaty, notwithstanding two attempts and a cross-country trip by the president to bring his argument directly before the American people.

Despite his failure to get the United States into the League of Nations and to secure all of his Fourteen Points in the Treaty, Wilson was awarded the Nobel Peace Prize. Concurrently, back on the home front, the indelible scars of war had left their mark. War bond campaigns rallied citizens to support their troops, women made unprecedented forays into the workforce, and children zealously participated in the activities, all amidst a pandemic.

Amid these tales of tenacity, poignant images of wounded soldiers returning home, and solemn war memorials rising as tributes to the fallen served as powerful reminders of the profound sacrifices made by individuals and communities in the pursuit of peace and liberty. Americans grappled with challenges of an unprecedented magnitude.

During this time, Woodrow Wilson's health deteriorated, followed by a stroke in October 1919. Edith Wilson's role became increasingly prominent. Her determination to shield her husband from the rigors of his office while maintaining a semblance of continuity in governance made her more than a "steward" of the president and the presidency—a role that had never been assumed by a First Lady.

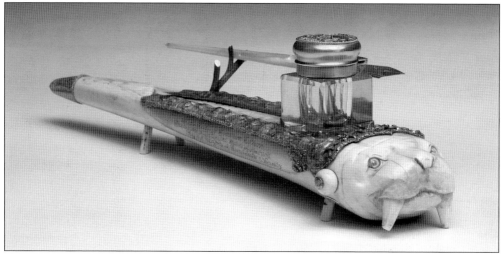

World War I turned much of the bucolic countryside of western Europe into killing fields. The United States suffered more than 53,000 combat-related deaths by the war's end in November 1918; a substantial number, though small compared to the 37 million-plus total casualties worldwide. Wilson signed the declaration of war with this pen, displayed on a walrus tusk and exhibited at the museum.

Seen here, the Wilsons at a "Preparedness Parade." Just a month after the end of the war, in December 1918, the Wilsons set off aboard the troop carrier USS *George Washington* to attend the Paris Peace Conference. Negotiations laid out at the historic conference would decide the future of Europe—and by extension the world. The values of American democracy would directly shape the course of world events.

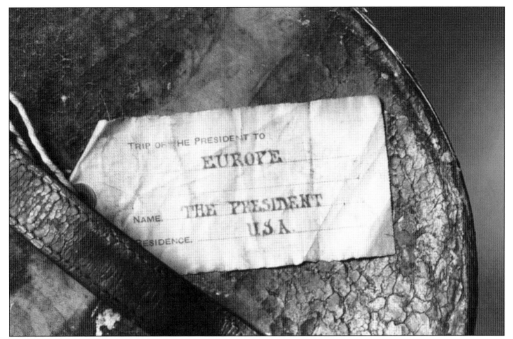

The United States was expected to play a leading role in the conference. As president, Woodrow Wilson would inescapably influence the trajectory of the peace negotiations. Wilsonianism was on parade. The Wilsons were specific about the clothes they wore for the trip. Understanding they were dressing for the world stage, they embraced fashion and diplomacy as a means of fashioning power. A diplomatic wardrobe required many trunks and cases.

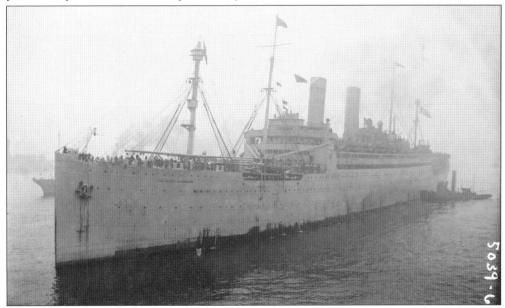

George Washington steamed into Brest, France, after 10 days at sea. Tugboats flying the tricolor welcomed the American flotilla to France. In a magnificent display of American naval power, *George Washington* was escorted by 10 battleships and 28 destroyers, some of which are seen at anchor flying stars and stripes in the background.

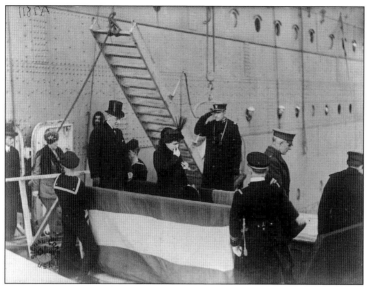

The Wilsons disembarked the *George Washington* for the tender to shore. It was the first time that a sitting president and First Lady had ever traveled outside North America—a momentous occasion. Sailors can be seen peering out of portholes. During the voyage, Wilson insisted on being served the same food as the soldiers and sat amongst them in the ship's cinema in the evenings.

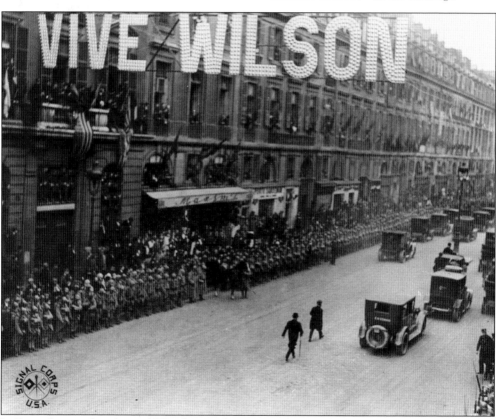

In Paris, thousands welcomed Woodrow Wilson. Since the Napoleonic Wars, imperial might had set the tone of politics in Europe. Many believed that secret treaties and arms races made global conflict inevitable. Wilson believed that nation-states should be designed "in the interest and for the benefit of the populations concerned, and not as part of any mere adjustment or compromise of claims amongst rival states." This appealed to Europeans weary of war.

The streets of Place de la Concorde in Paris were gridlocked. Edith Wilson recalled there being captured German guns on display. Photographs and newsreels depicted energetic crowds jubilant over the arrival of the American president. Some of these instances were undoubtedly staged, although that does not detract from the genuine public enthusiasm that World War I would be "the war to end all wars."

Wilson rode in the procession with French president Raymond Poincaré. When the Wilsons arrived in Paris by train at the Bois du Boulogne railway station, Poincaré and heads of the French military met them there. Edith recalled in her memoir that the train was that of the French president and that the cars were a little tired looking after years of war, not unlike France itself.

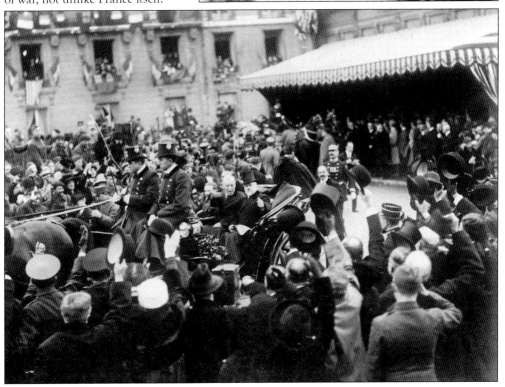

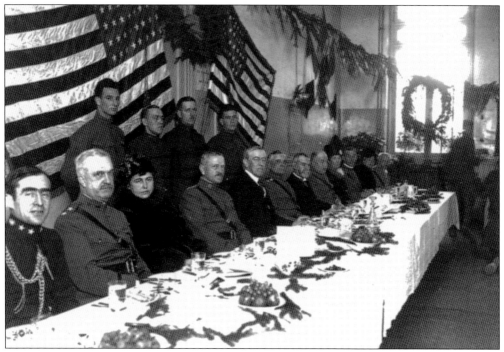

Christmas dinner with the American military team and American Expeditionary Force, Montigny le Roi was a quintessentially American meal that featured turkey and pumpkin pie, a confection that confused the French representatives present. From left to right are Adm. Cary Grayson; James McAndrew, chief of staff; Edith Wilson; Gen. John Pershing; President Wilson; Gen. Harry Clay Hale; Jules Jusserand, French ambassador to the United States; Gen. Hunter Liggett; Mme. Elisa (Richards) Jusserand; and Gen. Charles Summerall.

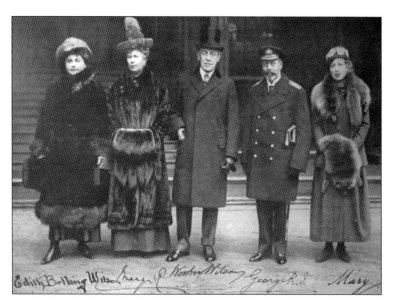

On December 26, 1918, the American delegation was welcomed at Charing Cross Station in London by members of the royal family and the prime minister. From left to right are Edith Wilson, Queen Mary, Woodrow Wilson, King George V, and Princess Mary.

A great victory parade in front of Buckingham Palace took place after the signing of the Armistice. Nearly 3,000 American soldiers marched through the city in an impromptu procession on December 5, 1918.

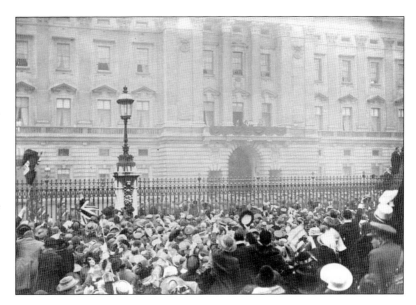

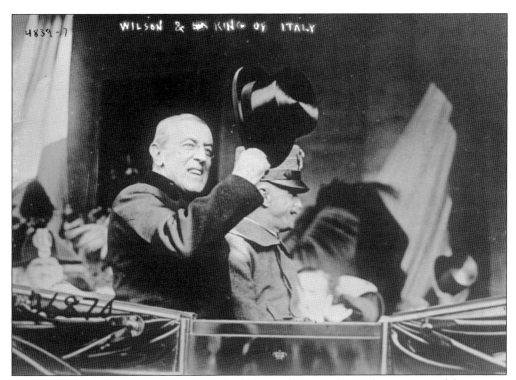

King Victor Emmanuel III of Italy dispatched his royal train to bring the American delegation to Rome in the first week of January 1919. Romans welcomed Wilson with cheers of "Viva l'America!" President Wilson remarked, "It has been a matter of pride with us that so many men of Italian origin were in our own armies and associated with their brethren of Italy itself in the great enterprise of freedom."

67

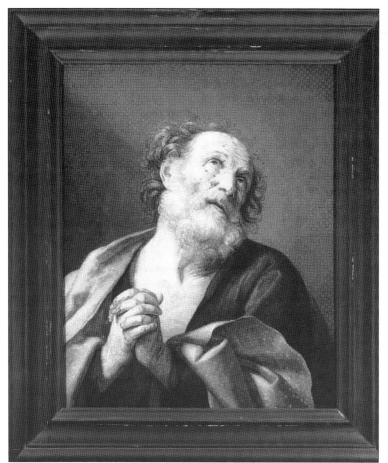

The first meeting between a pope and a US president took place in January 1919 at the Vatican between Benedict XV and Woodrow Wilson. On display at the museum is a gift from the pope in remembrance of the papal visit, a mosaic reproduction of Guido Breni's painting of the crucifixion of St Peter.

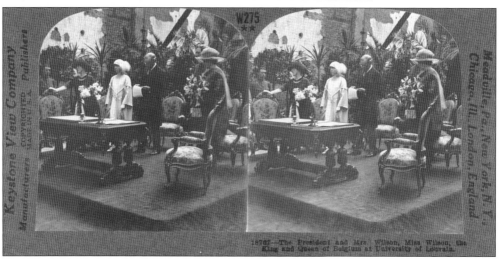

President Wilson visited with many kings and queens and heads of state during his visit. Pictured in June 1919 at the University of Louvain, from left to right are an unidentified soldier, Margaret Wilson, Elisabeth (queen consort of Albert I, king of the Belgians), Woodrow Wilson (reading an address), King Albert I (slightly obscured), and First Lady Edith Wilson.

After a week in Italy, Woodrow Wilson returned to Paris to set to work. Here, heads of the American delegation pose for a photograph during the conference. From left to right are Col. Edward House, Secretary of State Robert Lansing, Wilson, American peace commissioner Henry White, and Gen. Tasker Bliss.

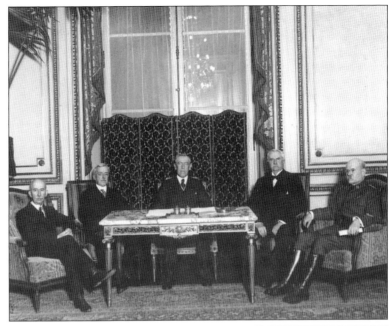

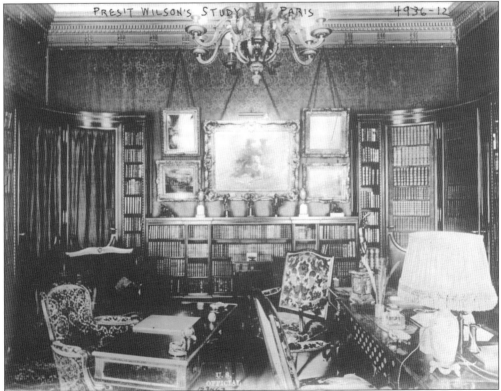

During their first time in Paris, the Wilsons stayed at the fashionable townhouse at 28 rue de Monceau. Generously loaned by Prince and Princess Joachim Murat, the house served as a working base for President Wilson during the peace conference. Referred to as a "hotel particulier" (or private home), seen here is the study where Wilson worked at the "Hotel Murat."

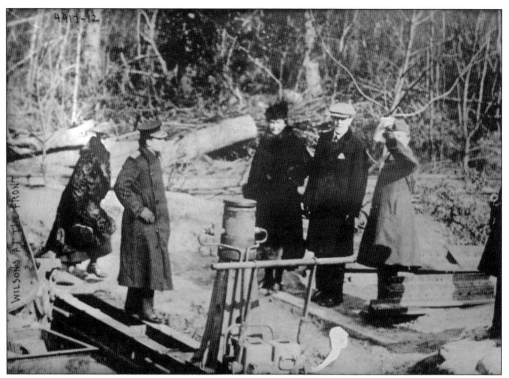

The devastation wrought by the war was horrific. President Wilson objected to visiting the destroyed cities, villages, and fighting fields fearing that witnessing the horror would sway him in the negotiations for peace. After the preliminary treaty was completed, he relented, and here, he is seen with Edith visiting the front.

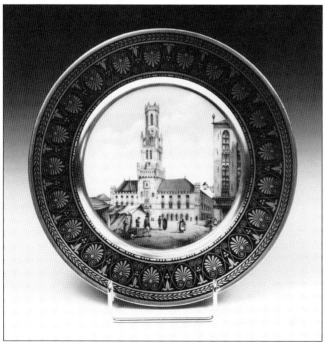

Belgium long served as a buffer state between antagonistic European nations. One of President Wilson's Fourteen Points centered on the restoration of Belgium and insisted on recognition of the country's sovereignty. The king and queen offered Wilson hand-painted plates (now on display at the museum) of many of the destroyed cities in Belgium.

Pax, a plaster sculpture of a standing young woman with a small girl next to her, was sculpted by Filipino sculptor Guillermo Tolentino in 1919. It was inspired by President Wilson's efforts at achieving peace at the war's end and gifted to him. It graces Wilson's bedroom fireplace mantel in the museum.

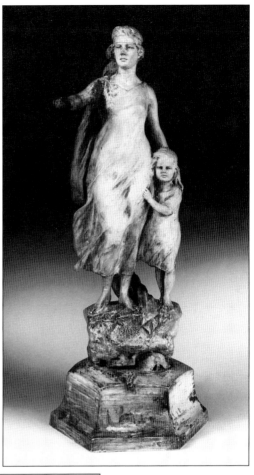

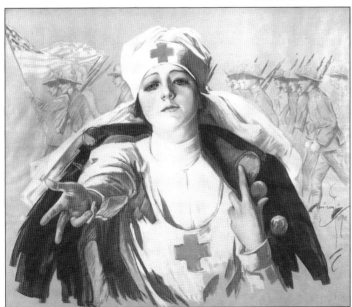

Six million civilians were killed between 1914 and 1918. About 300,000 homes were destroyed, and well over a million farm animals were killed. Wars of empire had devastated Europe for centuries, but never on this scale. "The Greatest Mother in the World" image by Harrison Fisher, which hangs in the museum, was used for the 1918 Red Cross poster "Have you answered the Red Cross Christmas Roll Call?"

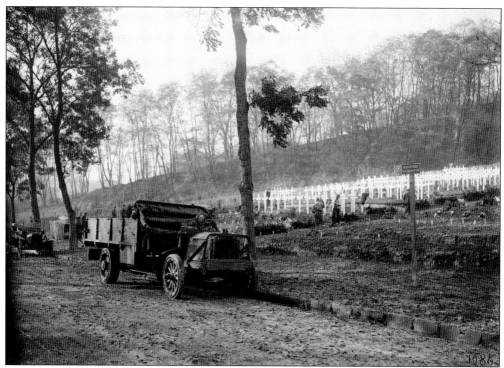

More than 40,000 American soldiers killed in action were buried in 593 different cemeteries across France. In his 1919 Memorial Day address at Suresnes, beside the graves of American soldiers, President Wilson emphasized the goal of the League of Nations to prevent future wars and drew comparison with soldiers who had died during the American Civil War: "These men have given their lives in order that the world might be united."

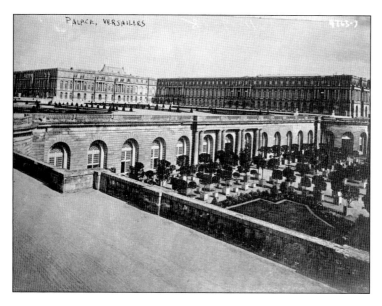

While President Wilson met with dignitaries in Paris, NAACP leaders, including W.E.B. DuBois and Ida Gibbs Hunt, organized a Pan-African Congress of 57 delegates representing 15 countries that simultaneously met in Paris. They sought to influence the peace talks, lobbying for the gradual abolition of European colonialism in Africa.

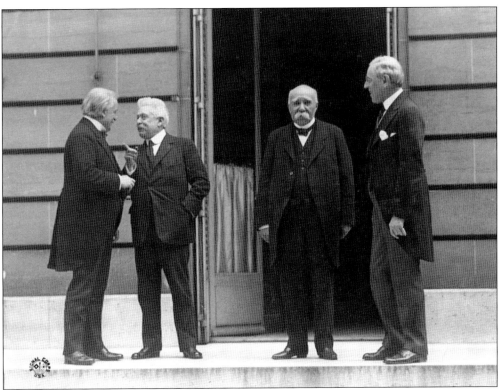

The leaders of the United States, France, the United Kingdom, and Italy—the "Big Four"—were the most prominent voices at Versailles. From left to right are Italian premier Vittorio Emanuele Orland, British prime minister David Lloyd George, French premier Georges Clemenceau, and American president Woodrow Wilson. The goals of territorial gain and punishment of Germany sometimes overlapped with—but often conflicted with—Wilson's agenda to foster democracy through his Fourteen Points.

While the Palace of Versailles was the primary backdrop for the Paris Peace Conference, the plenary sessions took place at the French Foreign Ministry building, seen here in the Salon de l'Horloge (Clock Room), Quai d'Orsay. President Poincaré of France is shown giving his opening address on January 18, 1919. A statue of the Roman goddess Victory dominates the room from a niche above the fireplace.

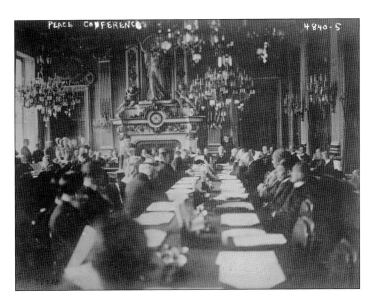

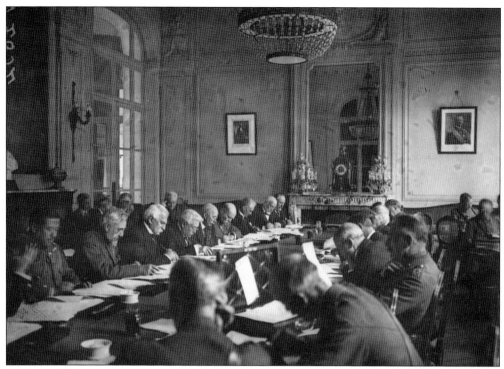

Wilson and his Fourteen Points championed an international structure designed to preserve a lasting peace based on sovereignty. The right of sovereignty was negotiated for European nations, although the idea was scarcely discussed at all for colonies and other parts of the world, except in former German colonies, which became mandates of the League of Nations.

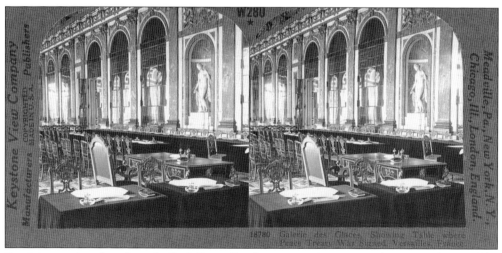

Surviving seating plans from the Paris Peace Conference reveal intriguing dynamics of power. The Big Four—Italy, France, the United Kingdom, and the United States—occupied the heads of most tables. Delegates from other countries not typically associated with the peace talks, including Haiti and Peru, were also assigned seats. No German representatives were assigned seats in any talks for fear their delegates might sow diplomatic discontent.

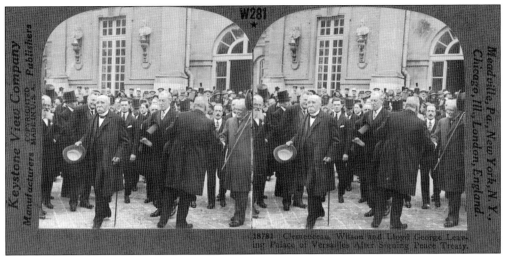

The Treaty of Versailles was signed in the Hall of Mirrors. Seen leaving are the leaders of the Big Four. The final draft of the treaty included President Wilson's vision of an international body designed to preserve peace: the League of Nations. Wilsonianism continued to influence ideas about America's role as a global leader and the right to national self-determination.

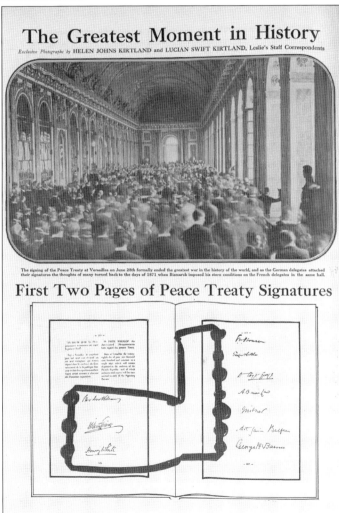

The entire existence of the German Empire was bookended by two major events that took place in this commanding room, the Hall of Mirrors in the Palace of Versailles. In 1871, the Proclamation of the German Empire was announced in the Hall of Mirrors, and less than half a century later, the terms of the German Empire's defeat were formally decided in the same room.

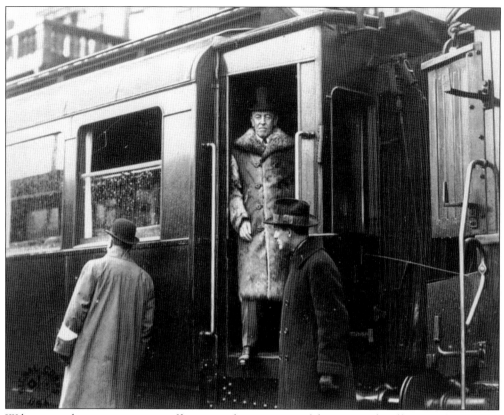

Wilson wore his iconic overcoat of kangaroo fur, now part of the museum's collection, throughout the trip. Preparing to leave Europe, he knew his biggest fight was ahead. The Senate had reservations about joining the League of Nations, fearing the United States would lose its own sovereignty. Wilson knew that he would have to leverage his popularity with the American people to push the ratification of the Treaty of Versailles through Congress.

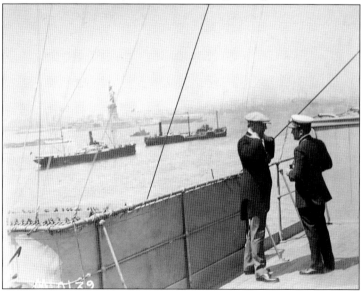

The *George Washington* arrived home in July 1919. Wilson, with a pair of binoculars around his neck, is seen here on the bridge with Rear Adm. Cary Grayson as the ship glides upriver past the Statue of Liberty. Small freighters are seen off the port side, having parted way for the flotilla to move upriver.

Edith Wilson, and others, recalled that one of the president's most endearing qualities was his sense of boyish curiosity. Wilson is seen here perched on the railing taking in the scene of their homecoming as smaller boats swarm around *George Washington*. Already wearing a tailcoat, the president changed his flat cap for his top hat before disembarking in Hoboken, New Jersey.

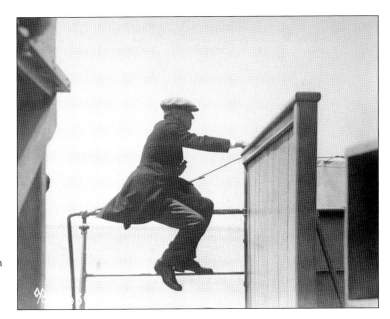

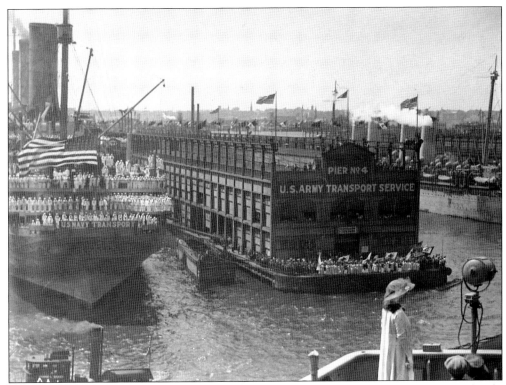

Sailors line the stern of the troop carrier *Leviathan* as the *George Washington* approaches her berth. To the right is the troop carrier *Von Steuben*. *Leviathan* and *Von Steuben*, respectively, were the former German passenger liners *Vaterland* and *Kronprinz Wilhelm*, seized at the outbreak of war as they were docked in American ports. *Leviathan* and *Von Steuben* were among the many dozens of ships Edith Wilson renamed during the war.

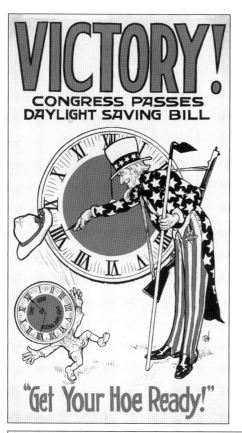

Meanwhile, on the home front, in March 1918, the Standard Time Act was signed into law by Wilson. Supporters of the bill believed the time change would lead to fuel savings and help the United States catch up to European nations who already used the system. George Creel, head of the Committee on Public Information, which some say was a propaganda organization created by Wilson, rallied support for the war and other initiatives.

The use of sheep on the White House lawn during World War I was a practical and patriotic measure that served multiple purposes, including addressing labor shortages and supporting the war effort. It also garnered attention and support from the American public. The sheep's wool was auctioned to support the Red Cross.

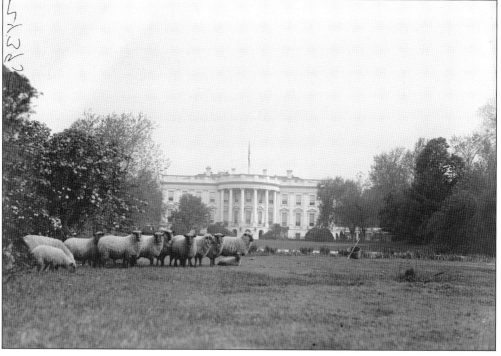

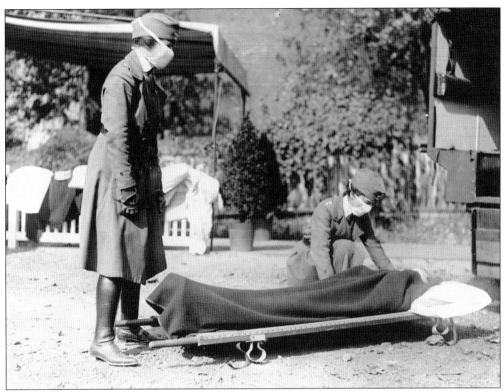

The Spanish flu (worldwide influenza pandemic) first broke out in February 1918. By the time the pandemic subsided in April 1920, there had been an estimated 500 million suspected cases, and it killed an estimated 50 million people. As seen here, outdoor housing (note blankets and tents in the background) and masking were the norm.

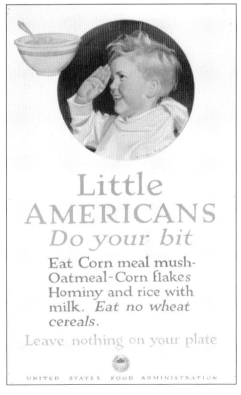

Rationing had a profound impact on daily life during wartime. Its purpose was to ensure equitable distribution of essential resources, manage shortages, and support the war effort. The restrictions and sacrifices of rationing were seen as a necessary measure to support the military and ensure that essential resources were directed toward the war effort. Rationing programs varied in intensity and duration during the war and among different countries.

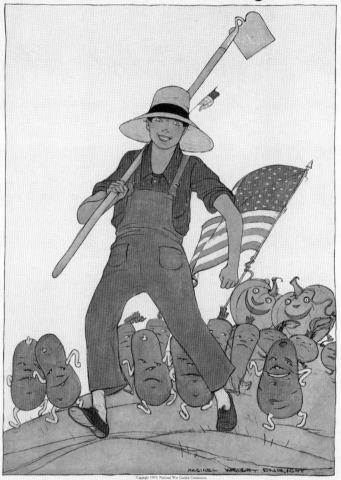

Victory Gardens were a significant part of home front efforts in the United States during World War I. Seen here, the *Seeds of Victory Insure the Fruits of Peace*, designed by Maginel Wright Enright, promoted a way for civilians to contribute to the war effort, conserve resources, and ensure a stable food supply during wartime.

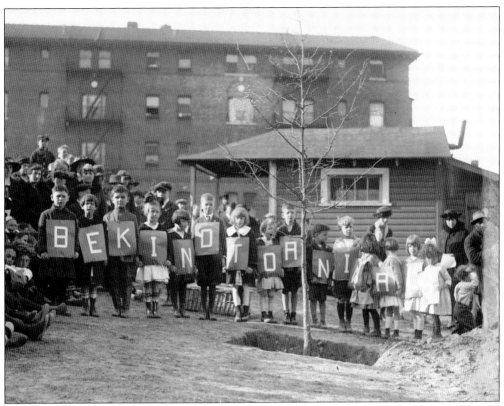

Children of the Municipal Playground at Eighteenth Street and Kalorama Road planted a tree in memory of the "dumb animals" killed during the war. This was one of the ceremonies in connection with the "Be kind to dumb animals" week. The tree entered the honor roll of the American Forestry Association on April 15, 1920.

Overall, there were four Liberty Loan drives held during the war followed by a fifth "Victory Loan" announced after the Armistice. Secretary of the Treasury McAdoo devised a mix of taxation and bonds to fund the American war effort. Seen here, a war savings stamp booth, Ninth and F Street NW in Washington, DC, in 1918.

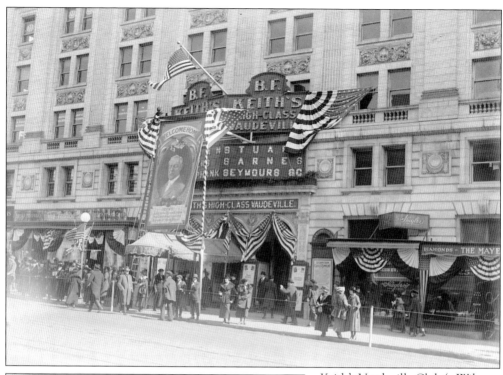

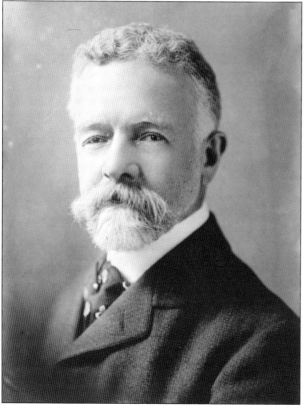

Keith's Vaudeville Club (a Wilson favorite) in Washington, DC, and the nation at large, welcomed Wilson home and supported his vision of the League of Nations and enduring peace. Ultimately, the treaty failed in the new Republican Senate. The League of Nations struggled to fulfill its mission without the support of the United States. Wilson was devastated and under tremendous strain.

Henry Cabot Lodge was an influential American statesperson and politician, best known for his prominent role in United States foreign policy and his long tenure as a US senator from Massachusetts. Lodge's career had a lasting impact on American politics, particularly in the realm of foreign affairs and his role in the Senate's rejection of the Treaty of Versailles and US membership in the League of Nations.

Washington was changing. Jeanette Rankin, a pioneering figure in American politics, became the first woman to serve in the US Congress. She was elected in 1916 to serve as a representative from Montana. At the end of her first term, Rankin ran unsuccessfully for the Senate in 1918. However, she was again elected to serve in the US House of Representatives in 1940, making her the first woman to serve nonconsecutive terms in Congress.

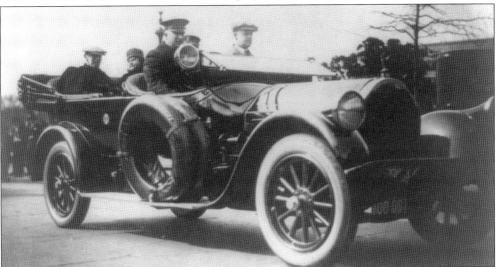

Wilson suffered a stroke in 1919 that left him partially incapacitated. Photographs showing the president in a convalescent state after his stroke in 1919 are extremely rare. Seen here is the first photograph of the First Couple after his stroke, with White House head chauffeur Francis Robinson, March 20, 1920.

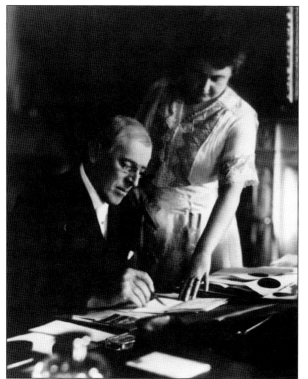

At the insistence of the president's doctors, Edith Wilson took an active role in protecting Wilson's fragile health after his stroke, becoming the sole line of communication between Wilson and his cabinet. Edith presented urgent matters to the president for consideration and relegated most other matters to department heads. This photograph was carefully staged to hide President Wilson's left side, which was incapacitated.

President Wilson (left) rode in an open car with Warren Harding to the Capitol before Harding's swearing-in as the 29th president on his inauguration day, March 4, 1921. Philander Knox and Joseph Cannon accompany them. After summoning an immense degree of physical strength to make this trip, Wilson retired from public service.

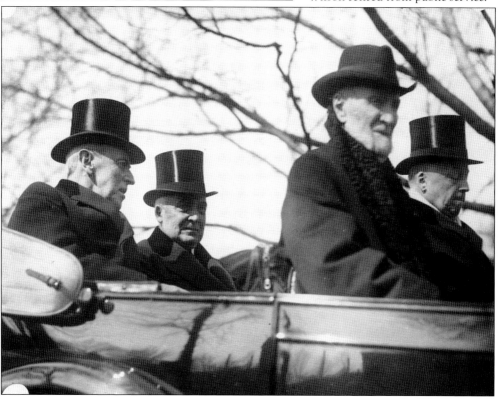

Seven
The Wilsons Retire to Washington

Pres. Woodrow Wilson and his wife Edith's retirement to Washington, DC, was carefully considered, involving a detailed comparison of potential cities. The nation's capital emerged as the top choice, not only because of its familiarity but also due to its practical benefits for the couple's new phase in life.

Key to their decision was the selection of a house on S Street, designed by the architect Waddy Butler Wood. The Wilsons had a clear list of needs: accessibility for Wilson after his stroke, space for a garage, a place where Wilson could open a law practice, and proximity to Edith's business interests, which would later become their main source of income. Edith Wilson discovered the house, which was state of the art in 1921, had all the modern conveniences of the day including a unique feature: a trunk lift. She envisioned transforming it into an elevator, a modification that would accommodate the president's mobility challenges following his debilitating stroke. It also had enough grounds on which to build a garage to house the president's car, which was a source of entertainment and activity almost daily. Edith's insight was not just about convenience; it was a testament to her unwavering commitment to her husband's dignity and quality of life.

After moving in on inauguration day 1921, Wilson formed a short-lived law partnership with his former secretary of state, Bainbridge Colby, which dissolved when Wilson was unwilling to lend his name as former president to the work. He considered running for a third term in 1924 to seek a referendum from the American people on the League of Nations.

The home was filled with his, hers, and their furniture and personal belongings including a vast array of gifts of state and mementos of his public career. This would be the first and only private residence the Wilsons would share.

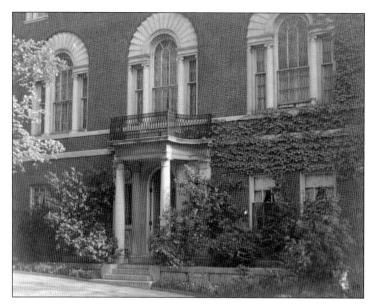

As Wilson's second term drew to a close, Edith searched for a quiet refuge to retire to after the White House. She found 2340 S Street NW in Washington's Kalorama neighborhood and fell instantly in love with the stately Georgian Revival house. Wilson presented the deed to her in December 1920, having yet to see the house in person.

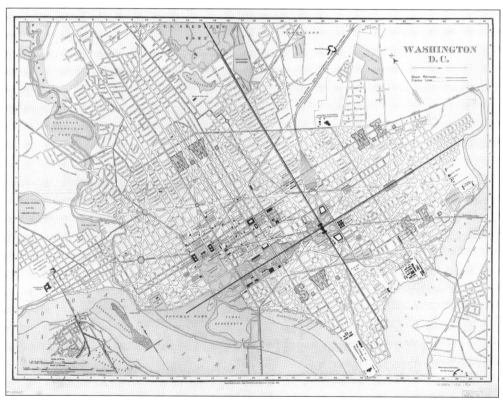

This is a map of central Washington, DC, and its immediate surrounding neighborhoods. The Wilson House is in the Northwest quadrant of the District of Columbia. Kalorama, Greek for "beautiful view," is a largely residential neighborhood bordered by Connecticut, Massachusetts, and Florida Avenues. It is just northwest of Dupont Circle.

The property at 2340 S Street NW mirrored the taste of its new owners: simple and elegant, stately but unpretentious. Lightwells built into either side of the house (seen on the right-hand side of this photograph) allowed additional light and ventilation into interior rooms. The house was intended to be attached to the houses on either side, as is evidenced by the lightwell.

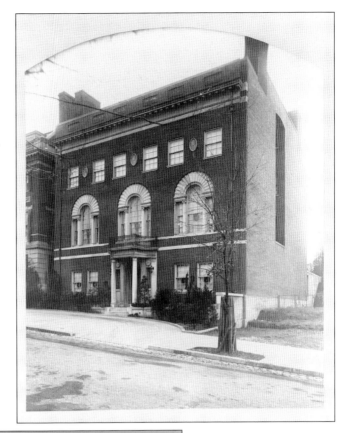

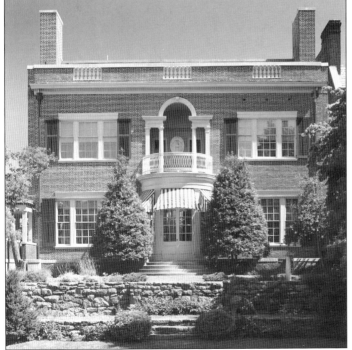

The property extends from S Street to Decatur Street, just south of S Street, and onto Massachusetts Avenue, now known as Embassy Row, the grandest boulevard in all of Washington, DC, at the time. Although quiet and secluded, S Street was still close to the halls of power. The rear view of the house is seen from the garden.

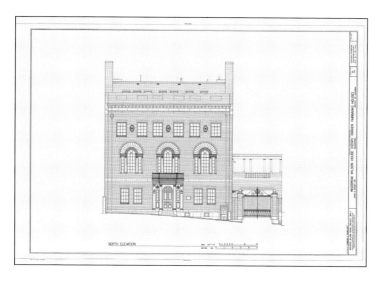

The Historic American Building Survey (HABS) rendering of the front of the house. The Wilsons' new, very modern home and stately gardens were designed by renowned architect Waddy Butler Wood. The house was originally built just a few years earlier as a private residence for Henry Parker Fairbanks, an executive at the Bigelow Carpet Company.

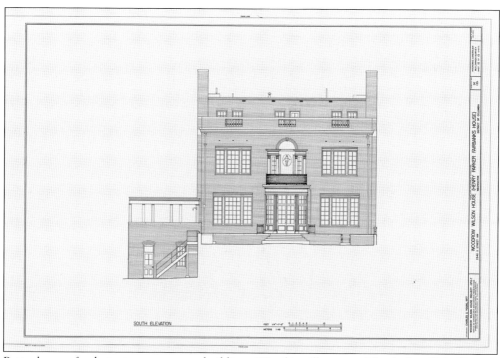

Better known for designing government buildings, Wood is still respected for the handful of houses that he designed in Kalorama and nearby Dupont Circle. The house comprises a cellar and four floors above grade. Due to the rocky hillside the house was built into, as well as the brick parapet, only the second and third floors are visible from the garden, as seen in the rear perspective.

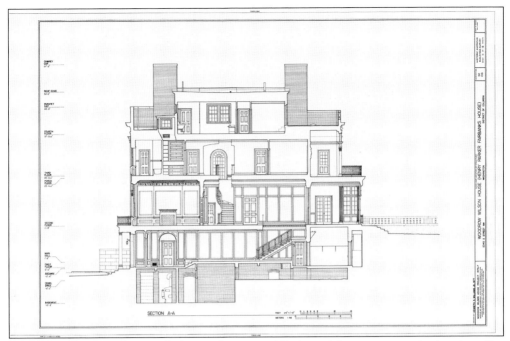

The HABS rendering dissects the house, facing east. The house's basement contained a wine cellar and utility space. The ground floor above, which was partially underground as well, contained the entrance hall, kitchen, and reception rooms.

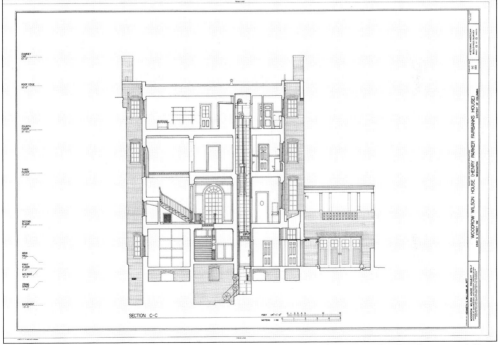

The HABS rendering here looks at the house from the front, facing south. On the second floor are the drawing and dining rooms and the library. The third floor is devoted to the bedrooms, and the fourth floor was home to the Wilsons' domestic staff, and laundry.

STATEMENT OF ACCOUNT

JOINT OFFICES OF
THE REAL ESTATE TITLE INSURANCE COMPANY OF THE DISTRICT OF COLUMBIA
THE COLUMBIA TITLE INSURANCE COMPANY OF THE DISTRICT OF COLUMBIA
800 FIFTH STREET, N. W., WASHINGTON, D. C.

WASHINGTON, D. C., February 4, 1921

The Real Estate Title Insurance Company of the District of Columbia
The Columbia Title Insurance Company of the District of Columbia

Settlement Case No. _____ To Mrs. Edith Bolling Wilson _____ DR.

In Re _____ Purchase _____ Lot Part of Lot 22, Lots 13 & 23 Square 2517

```
Price of Property                                         $150,000.00
Certificate of Title                                           175.00
Tax Certificates                                                 1.50
Preparing deed                                                   5.00
Recording deed                                                   1.10
Settlement fee                                                  75.00
Survey                                                          14.00

Taxes on Lots 13 & 23 @ $948.68 - pro rata             $    569.3
Taxes on part of Lot 22, being purchased,
which includes 2,023.20 sq. ft. -
20 by 101.16 ft. @ $2.25 per sq. ft.,
Advanced by the purchaser - - - $281.19
Amount chargeable to purchaser on account
of part of Lot 22, being pro rata portion
from date of possession - February 4th
to July 1, 1921. - - - - - - - -    36.06
Amount chargeable to seller on account
of advance by purchaser on the above taxes                    245.1
Deposit                                                     5,000.0
Balance of purchase price due                             144,457.
                                                         $150,271.60  $150,271.6
```

Edith Bolling Wilson

Balance of purchase price due Feb. 3/21 in 144,457.16

Paul S. Anderson
Asst Settlement Clerk

As seen here, the house was sold to Edith on February 3, 1921. She had just one month until she would move out of the White House. Edith Wilson orchestrated a hasty series of improvements to the house on S Street to make it more comfortable for her partially incapacitated husband. The many additions included an Otis elevator, a garage, a billiard room, and stacks for Wilson's expansive book collection.

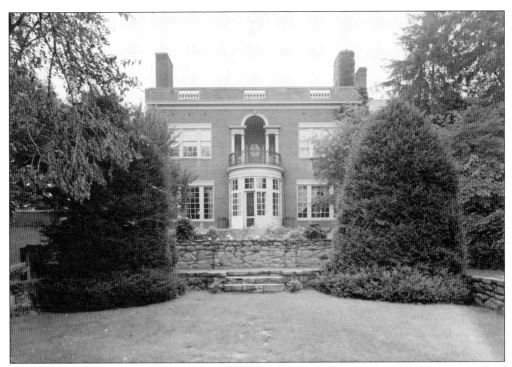

Wilson's library consisted of over 9,000 volumes. Edith would say the house "suited the needs of a gentleman."

Just a generation before, Kalorama remained wooded and undeveloped. By the 1920s, affluent homes of businessmen transformed this corner of Washington into a quiet suburb. With the stock market crash a decade later, many of the private homes became embassies, creating what is known today as Embassy Row. The garden was designed by Waddy Wood as well, and the structure of the garden has been untouched for over 100 years. Recently, the garden has been rehabilitated to its original splendor with sustainable and environmentally sound native plants.

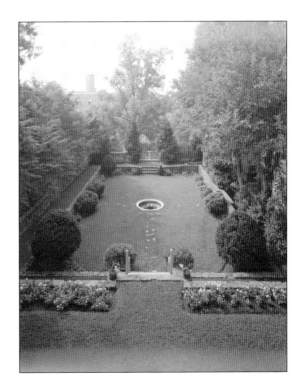

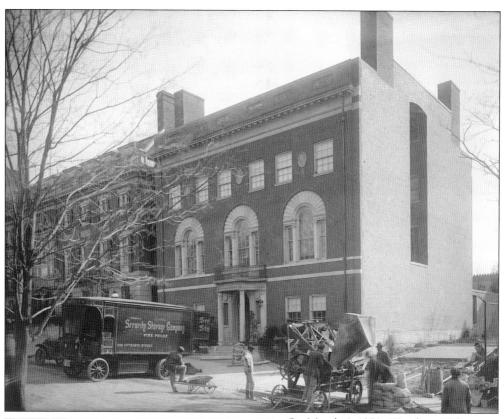

On March 4, 1921, Woodrow Wilson left the White House for the final time and settled directly into S Street. In this image, work at the house was well underway, as workmen poured a new concrete driveway while a moving van unloaded furniture. Although his life no longer hung in the balance, Woodrow's health was still fragile. Edith's mission was to make their new home safe and comfortable for her husband.

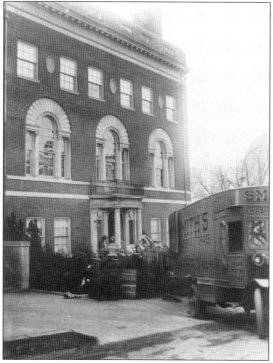

The Wilsons bought the house from the Fairbanks for $150,000. Woodrow had just been awarded a Nobel Peace Prize of $50,000, and 10 friends each gave him $10,000 to make the purchase. Here, more furniture and possessions are seen being unloaded from another moving van. Fragile possessions were packed in wooden crates and barrels. The barrels were remarkably easy to move.

Upon entering the "American Basement Plan" building, the ladies' cloakroom is to the right. The men's cloakroom, to the left, seen here head-on, was converted to Edith's brother's office; it is also known as "the Dugout," a nod to Wilson's love of the game of baseball.

Among the list of improvements Edith made to the house, a set of French doors was added in the southwest corner of the dining room to access a new terrace. Above the fireplace hangs Seymour Stone's portrait of Edith, which she rejected as her official White House portrait because she felt it portrayed her "too young, too thin, and too authoritative."

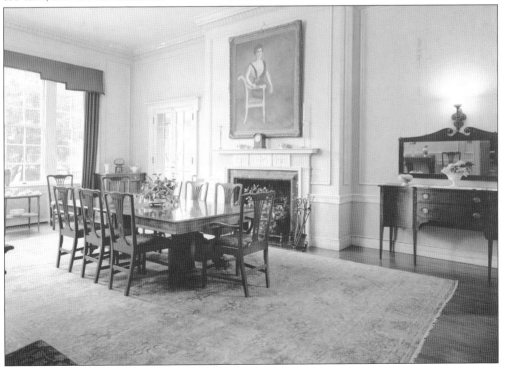

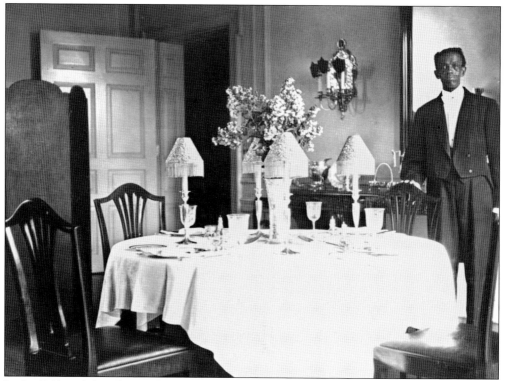

In the 1940s, Edith Wilson and several of her friends covered the dining room chairs in needlepoint they had made themselves. Most have the needle pointer's initials in the pattern. The former First Lady would invite every First Lady who succeeded her to luncheon here at least once. Her last invitee was First Lady Jacqueline Kennedy. Seen here is one of the Wilsons' several staff, dressed in livery.

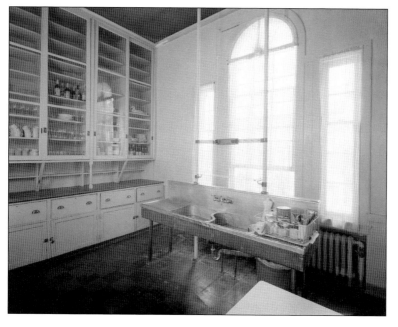

Just beyond the dining room door is the butler's pantry complete with a zinc sink. The beautiful Palladian windows repeat along the front facade, regardless of the use of the room, for the sake of symmetry, balance, and elegance.

Next to the terrace and perched atop a short flight of steps above the garden is the solarium, where Wilson enjoyed his breakfast each morning. While some of the formal garden's privacy has been sacrificed with subsequent development, the view from the solarium has not changed since the 1920s.

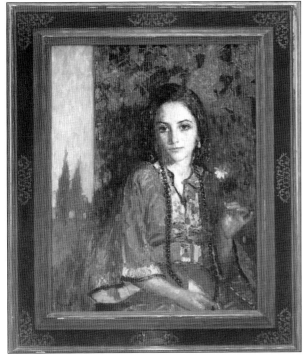

Above the fireplace in the drawing room is the portrait *L'Esperance* by Hoovnan Pushman, an Armenian, a gift from the people of Armenia to Woodrow Wilson in thanks for his recognition of the Armenian genocide. It hangs there today.

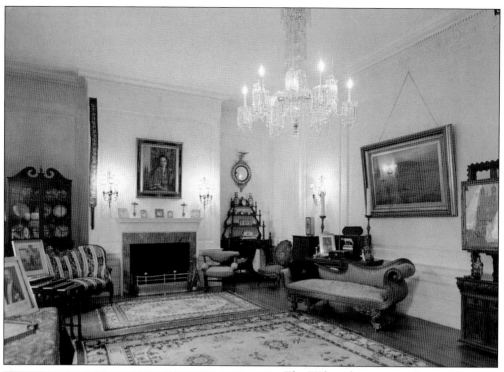

The Wilsons' taste was eclectic. Their collection of furniture reads as an album of their journeys through life, both individually and together. Included in the Woodrow Wilson House's vast collection are Wilson's desk from Princeton, Edith's settee from her home in Dupont Circle, mementos from trips abroad, and gifts of state from around the world.

From another perspective of the Wilsons' drawing room, a Gobelin tapestry gifted to the Wilsons by the people of France following World War I, dominates the wall opposite the fireplace. Like many pieces in the Woodrow Wilson House, the tapestry does not fit the scale of the room. However, like every piece of furniture the Wilsons owned, it is rich in meaning and significance.

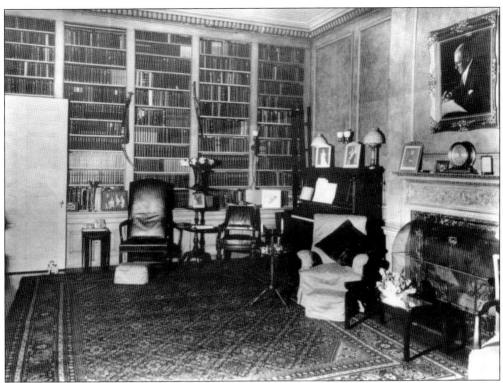

The most intimate room in the Woodrow Wilson House is the library. Lined with books and decorated in warm tones, it was a favorite retreat for Wilson, where he spent most of the day. Wilson was a well-known admirer of technology throughout his life. He particularly enjoyed watching films and in the evenings was fond of watching them on a projector in the library. A screen was rigged to hang in front of the bookshelves.

In Wilson's bedroom on the third floor, above the fireplace hangs a copy of Edith's official First Lady portrait, originally a gift from Col. House upon the Wilsons' engagement. The original hangs in the White House today.

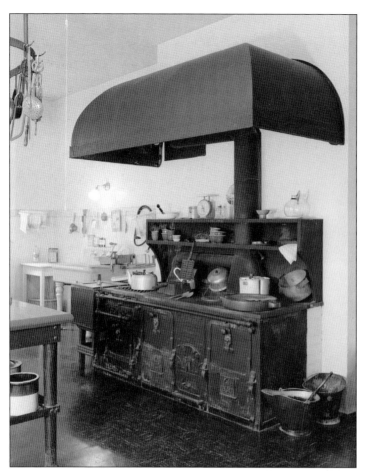

The kitchen, located on the ground floor, houses the original stove, both coal-fired for the winter and gas-operated in the summer, making it completely state-of-the-art in 1916.

The Woodrow Wilson House received only minor updates during Edith's 40 years in residence; however, those updates were added to the house without depriving it of its historical integrity, as seen by the modern electric stove in the far corner.

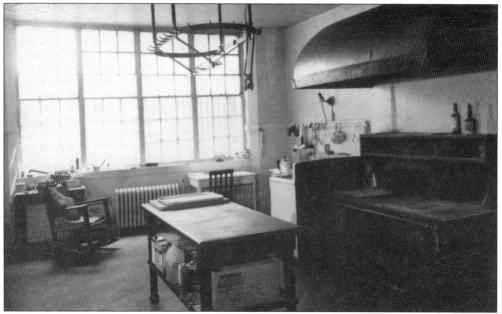

The house also features a wine cellar on its lowermost level, an extraordinary room to have during the age of Prohibition. Much of the alcohol that the Wilsons had in storage in this space were gifts of champagne and wine from the French ambassador, whose residence was nearby on Kalorama Road.

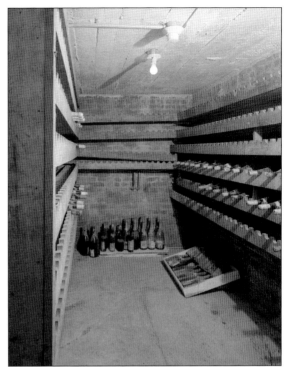

Also housed in the basement are the Otis elevator mechanics. Installed over 100 years ago, the elevator is one of the oldest still-operating elevators in North America.

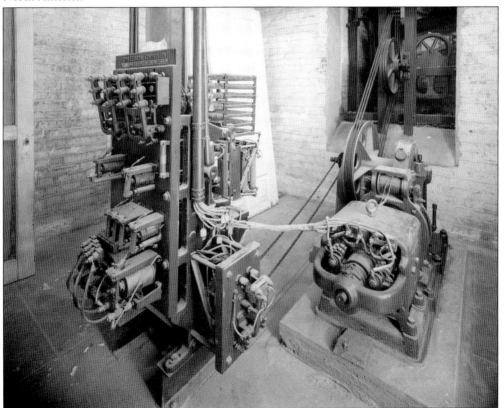

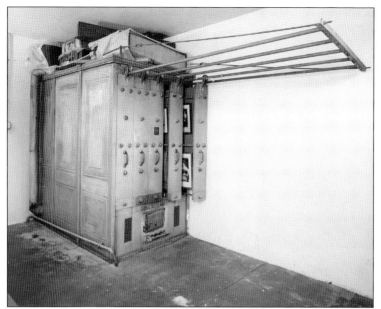

The historic laundry room is located on the fourth floor. Seen here is the original gas-fired clothes dryer. The laundry room also had five large wash sinks, a mangle, and a gas-heated iron grid with various weighted and sized irons. The fourth floor also has a bathroom with a sink, toilet, and claw tub with a showerhead, which have been replumbed to function for staff today.

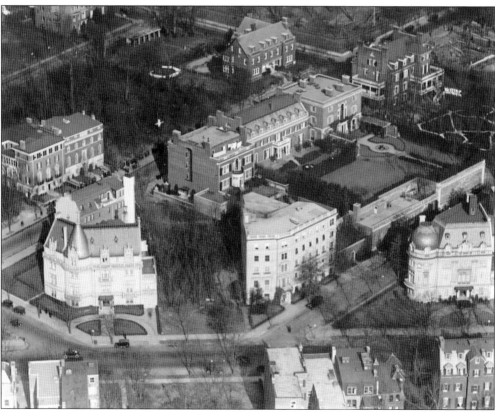

This is an aerial view of the Woodrow Wilson House (center). Kalorama developed slowly, even well into the 20th century, as evidenced by the vacant lots around S Street. If one looks closely, laundry can be seen hanging on a clothesline behind the parapet on the fourth floor of the house. The laundry facilities were on this floor.

Eight
LIFE ON S STREET

The story of the S Street house is as much about the people who lived and worked alongside the Wilsons as it is about the former president and First Lady. Isaac and Mary Scott were the valet and housekeeper for the Wilsons, living in the house for a decade and continuing to work there into the 1950s. In her memoir, Edith Wilson remarked of the Scotts, "I count them high on my list of this world's blessings."

Along with the Scotts, Edith's brother John Randolph Bolling also lived at 2340 S Street, occupying the third-floor bedroom that is now the museum's executive director's office. Bolling worked as President Wilson's private secretary after he left office.

Part-time staff also commuted to S Street when needed. In 1921, these included George Howard, the chauffeur; John Rupple, the night nurse; a laundress once a week; and a cook for all but the simplest meals. As Wilson's health deteriorated, there were additional nurses who rotated in and out; their imprint on the house remains in our collection of modern (for the time) medical devices on display.

In later years, relatives of Edith Wilson lived with her here at various times. The museum is committed to continuing to research the histories and experiences of all those individuals who lived and worked in the house.

Armistice Day, November 11, held profound significance for Wilson. It was the day that marked the end of World War I and the beginning of hope for lasting peace. Wilson's commitment to the principles of the League of Nations and his vision for international cooperation remained unwavering. Each year, he addressed crowds on this momentous day, using the occasion to underscore the vital importance of collective security and diplomacy in preventing future conflicts. His speeches reveal a man who saw Armistice Day not just as a historical marker, but as a call to action.

On the eve of the fifth anniversary of Armistice Day, November 11, 1923, the S Street house became the site of a landmark historic event when the former president made the first nationwide remote radio broadcast to commemorate the day.

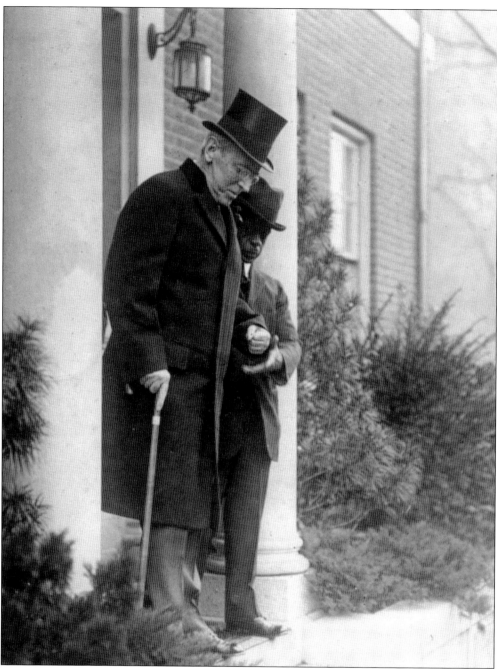

Isaac (1875-1959) and Mary Scott (1882-1968) served the Wilsons at their home on S Street for many years. Isaac Spencer Scott was born and raised in Washington, DC, and for 20 years worked as a porter for the Galt & Bro. jewelry store owned by Edith Bolling's first husband, Norman Galt. The Scotts joined the Wilsons' service at S Street in March 1921 and lived on the fourth floor.

Isaac's wife, Mary, ran the house. In August 1931, the Scotts purchased their own home at 4434 Hunt Place NE in the Deanwood neighborhood of Washington, DC. Initially, they spent only one night a week at their new home, spending the rest of their time working at S Street. Later they commuted to work by streetcar. Isaac and Mary continued in Edith Wilson's service at S Street into the 1950s.

A meticulously dressed Isaac Scott is pictured in the garden having apprehended a trespassing opossum. Relatives of Isaac and Mary Scott still live in the District of Columbia and are actively involved in telling the stories of the many lives involved in the long history of the Woodrow Wilson House, including Isaac and Mary.

Seen behind a weary Woodrow Wilson on his front stoop is Isaac Scott. After his own health declined, Isaac died on May 30, 1959, at the age of 83. Edith Wilson attended his funeral and visited the family at their home on Hunt Place afterward. Mary Scott died on January 15, 1968, at the age of 85. The couple are buried at National Harmony Memorial Park Cemetery in Landover, Maryland.

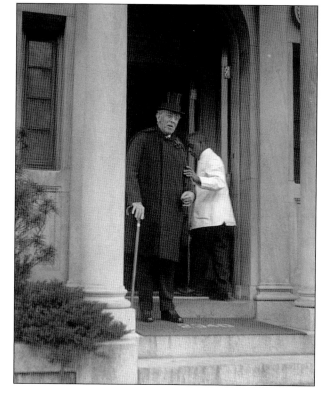

Woodrow Wilson stands on the house's front stoop on his 65th birthday, December 28, 1921. Time and age had diminished much of the former president's vigor, although the iconic profile of his top hat still evoked the visage of a wartime president whose crucial decisions defined an age, both at home and abroad.

Woodrow Wilson was the last American president to ride to his inauguration by horse-drawn carriage. However, his love for the automobile is not to be understated. Edith Wilson had a garage constructed to shelter the Wilsons' automobile as seen in the background beneath the terrace. The elevator's ground-level landing was just inside the door visible in the background, facilitating ease of access. George Howard was the long-serving chauffeur to the Wilsons.

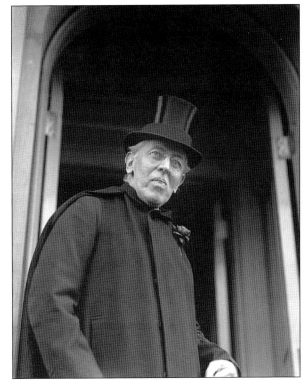

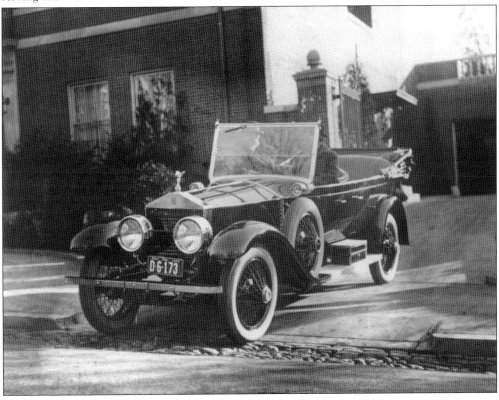

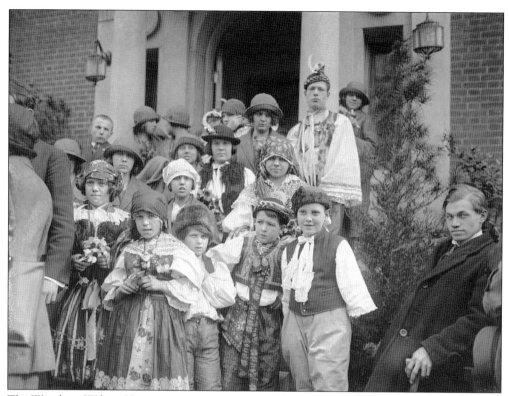

The Woodrow Wilson House saw many visitors, including this group of children from the Czech Republic. In addition to ethnic visitors, the Wilsons entertained family, politicians, and diplomats from around the world, from retired diplomats they had met on their trips to Paris in 1919 to those who were in the halls of power.

The Wilsons are seen riding in an open-air carriage during the 1921 Armistice Day procession. Both the current president, Warren Harding, and the former president, Woodrow Wilson, were invited to witness the entombment of the Unknown Soldier at Arlington National Cemetery. President Wilson had laid the cornerstone for the new amphitheater at the cemetery in 1915.

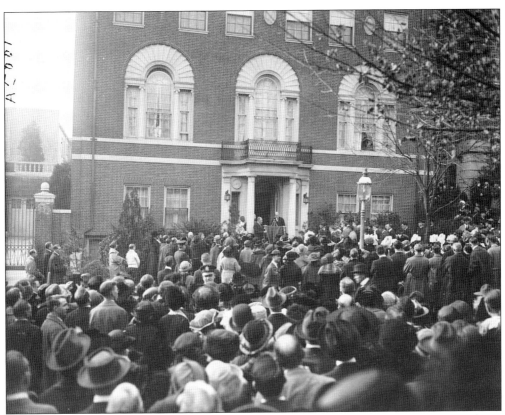

Armistice Day was a day of remembrance, gratitude, and reflection on the sacrifices of military veterans. It highlighted the importance of peace and the need to support and honor those who had served in the armed forces. On Armistice Day 1922, Woodrow Wilson stepped out on the front stoop to meet an assembled crowd.

In 1954, President Eisenhower signed legislation that changed the name of Armistice Day to Veterans Day. This change was made to honor and include all US military veterans, recognizing their contributions to the nation's security in all wars and conflicts.

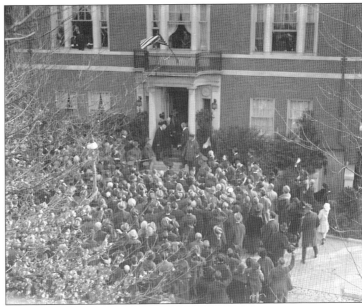

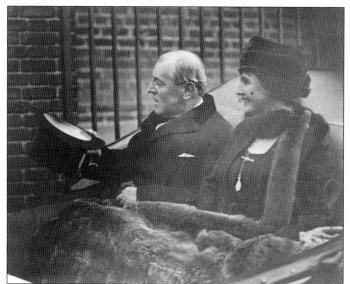

Wilson's public appearances while in retirement were rare. His limited appearances were curated in ways that concealed the full extent of his disability, by minimizing physical movement and unscripted speech as much as possible. On Armistice Day, however, he would speak to the crowds and attend celebrations. Seen here, the Wilsons are departing S Street for Armistice Day celebrations in 1922.

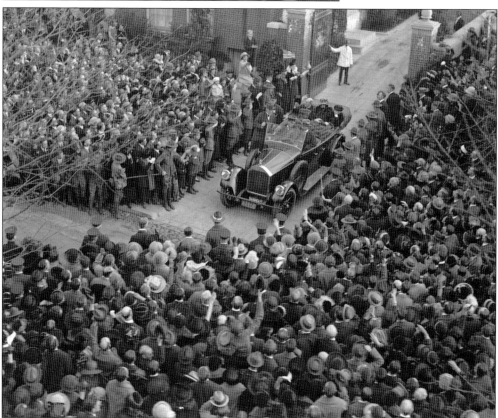

In an aerial view from 1923, the Wilsons are seen departing S Street. Visitors crowded the streets. Wilson, like many presidents, made decisions during his administration that generated considerable criticism and affected the ebb and flow of his popularity. Despite that inherent dynamic of the presidency, Wilson remained so revered into his retirement that the house on S Street became a fixed point of pilgrimage for many Americans.

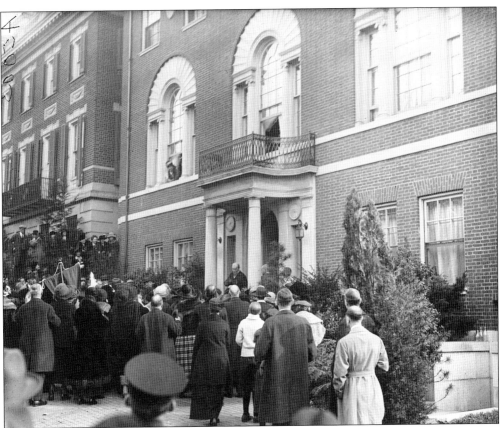

After the end of the war, the isolationism that came to define American foreign policy in the 1920s and 1930s became firmly established. Many Americans continued to admire Wilson's vision of world peace. Privately, Woodrow Wilson, seen here on the stoop, was haunted by America's failure to ratify the Treaty of Versailles and join the League of Nations.

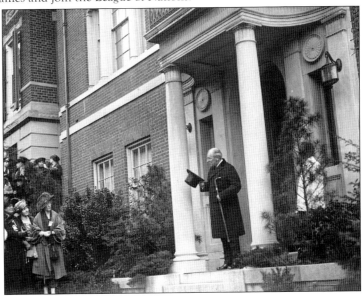

Woodrow Wilson is seen here on Armistice Day, 1922. The *Portsmouth Star* recalled the following day, "Sick as he has been, Woodrow Wilson is still and will continue to be the moral leader of the American people . . . he has voiced for them their highest ideals. He won for them the admiration and respect of the world."

On November 10, 1923, the eve of the fifth anniversary of Armistice Day, the S Street house became the site of a landmark historic event when the former president made the first remote nationwide radio broadcast to commemorate the day from his S Street library.

In his Armistice Day address, he lamented that the day would be "forever marred and embittered for us by the shameful fact that . . . we turned our backs on our associates and refused to bear any responsible part in the administration of the peace." Privately, Wilson was haunted by what he considered the greatest failure of his administration.

The Armistice Day eve crowd of some 5,000 "friends and admirers" clogged S Street. Woodrow Wilson's smooth tenor voice, long known for its adeptness at public speaking, had faded with age and poor health. Still, the former president's passion for peace endured: "Armistice, as I have said, is a mere negotiation: it is a refraining from force."

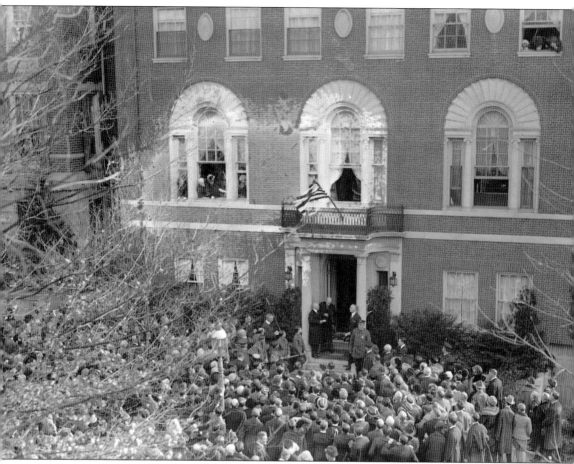
The next day, Woodrow and Edith Wilson greeted the crowds from a drawing room window overlooking S Street and the crowds. It would be Wilson's last public appearance.

Nine

PRESERVING WILSON'S LEGACY

The death of Woodrow Wilson on February 3, 1924, marked the end of an era in American history and the beginning of a chapter that would be defined by a legacy of unparalleled influence. This was a somber and reflective moment in time, where the nation bid its farewell to the 28th president of the United States through a poignant funeral ceremony. However, it equally marked new departures as Edith Wilson, his devoted wife, assumed the role of steward for his memory and ideals, ensuring that his legacy would continue to resonate in the annals of American governance.

The images that capture the solemnity of Woodrow Wilson's funeral procession and burial reveal a nation in mourning. Crowds lined the streets, dignitaries were in attendance, and a procession embodied the profound respect and admiration that the American people held for their former leader. As the procession made its way through the streets of Washington, DC, and finally to the Washington National Cathedral, it was a moment of reflection not only on the man but also on the era he had defined—an era that had witnessed the United States grapple with the challenges of World War I and the subsequent quest for peace.

Yet this was not only a time of farewells. It was equally a testament to Edith's dedication to preserving her husband's legacy. Following Woodrow Wilson's death, Edith became a guardian of his memory and ideals. She championed causes dear to him, participated in memorial ceremonies, and advocated for the League of Nations, a cause in which he had fervently believed. Edith's unwavering commitment to promoting her husband's vision continued long after his death, ensuring that his ideas would remain a vital part of American political discourse.

Edith nurtured Wilson's legacy with grace and determination. The legacy of Woodrow Wilson lives on, in no small part due to the steadfast support and advocacy of Edith Wilson, a woman who stood as a guardian of ideals that continue to shape the nation.

By the morning of February 3, Wilson's health had begun to spiral, and it had become apparent that his death was near. A crowd gathered kneeling in prayer on the sidewalks and banks outside 2340 S Street NW as it became evident that the former president's life was ending. Wilson drifted out of consciousness and died peacefully shortly thereafter in his bedroom upstairs on the third floor.

Upon Woodrow Wilson's death, the crowds on S Street house continued to grow, now reading of his death in the newspapers. Embassies of the Allied nations dispatched representatives to S Street to pay their respects. Former prime minister David Lloyd George, with whom Wilson had negotiated and sparred in Paris remarked, "He now belongs to the ages: a man of high ideals and deep sincerity, and of indomitable courage."

The Episcopal bishop of Washington was enlisted to officiate Woodrow Wilson's memorial service, along with the two Presbyterian pastors from the churches where Wilson had worshiped in Princeton and Washington. Wilson, in a departure from what is normally expected of a former president's funeral, had no wishes for an extravagant ceremony or to lie in state at the Capitol Rotunda.

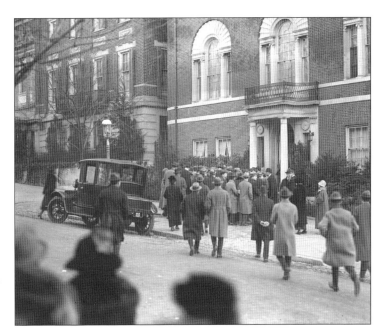

A news syndicate installed a wire outside the Wilson house, allowing news reporters to share live updates of the day from New York to Chicago. When Woodrow Wilson entered the world in 1856, news throughout large swaths of America still spread at the speed of horseback. The world he had witnessed—and helped shape—had changed enormously.

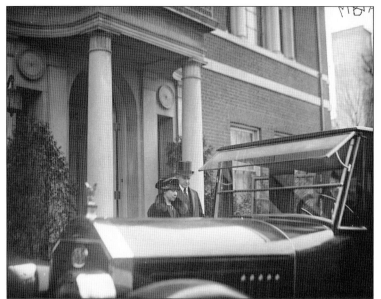

A steady stream of mourners visited the Wilson residence to pay their respects to the now-widowed Edith. Woodrow Wilson had actually outlived his successor. Here, Pres. and Mrs. Calvin Coolidge left by car. Pres. Warren G. Harding had died on August 2, 1923, of a heart attack, and Coolidge, who was serving as vice president at the time, succeeded him as president.

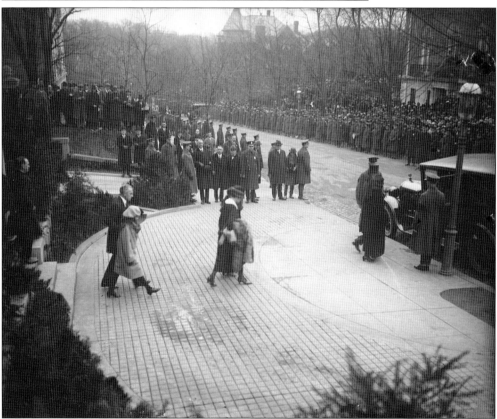

Seen here, family members are leaving the S Street residence following Edith Wilson and her brother Wilmer. By now, well into the age of mass media, cameras and film reels captured Edith from many angles exiting the house in her widow's veil. It was one of the first times that technology allowed a former president's funeral to be recorded so widely.

Pallbearers for the former president's funeral were selected from the Army, Navy, and Marine Corps. After the funeral of Wilson's successor, Pres. Warren G. Harding in August 1923, which Wilson attended, the funeral of Woodrow Wilson was the second presidential funeral in six months. Only on four occasions in American history have two former—or current—presidents died less than six months apart.

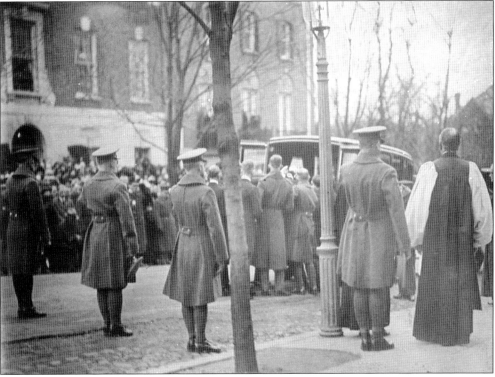

The hearse and lengthy cortege—composed of Edith, the Wilson family, friends, and dignitaries—parked on S Street as they prepared to depart for the cathedral where Woodrow Wilson was to be interred. Wilson is the only president to date whose final resting place is in the District of Columbia. Tens of thousands of people gathered in the streets of the nation's capital to pay their respects to the former president.

The cortege arrived at the National Cathedral, and the president's coffin was conveyed from the hearse to the Bethlehem Chapel of the National Cathedral, which was still in the beginning stages of construction. At the time of Woodrow Wilson's death, only the apse of the National Cathedral and the crypt below had been finished.

Woodrow Wilson is laid to rest in the National Cathedral. His faith played a significant role in his presidency, influencing his policies and worldview. He also faced criticism and challenges, particularly in matters related to civil liberties and civil rights during his presidency. Wilson's approach to these issues, including his handling of racial segregation in the federal government, remains a subject of debate and critique.

The Order for the Burial

of

His Excellency, Woodrow Wilson

President of the United States of America
from March 4, 1913, to March 4, 1921

Washington Cathedral
The Bethlehem Chapel of the Holy Nativity
Wednesday, February Sixth
A.D. 1924

Wilson was buried on February 6; however, later that year on December 15, 1924, the House of Representatives held memorial exercises in memory of the late Woodrow Wilson. In attendance for the exercises were Pres. Calvin Coolidge, his cabinet, Justices of the Supreme Court, members of the House of Representatives, governors, generals, ambassadors of foreign governments, and invited guests.

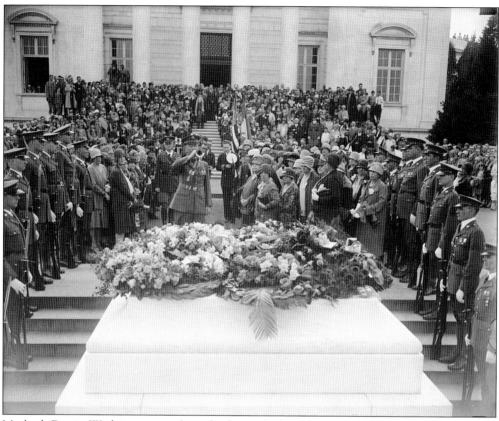

Mother's Day in Washington was fittingly observed when the American War Mothers, many of them Gold Star Mothers, journeyed to Arlington National Cemetery, where they paid tribute to America's Unknown Soldier. This scene shows Sgt. Frank Witchey, who sounded Taps when the Unknown Soldier was buried on November 11, 1921, again sounding Taps after the mothers placed wreaths on the tomb.

In 1944, Darryl Zanuck's film *Wilson* starred Alexander Knox, Thomas Mitchell, Charles Coburn, and Geraldine Fitzgerald, among others. Emphasized in its plot was Woodrow Wilson's disappointment over America's rejection of the Treaty of Versailles. The immensely popular film received positive reviews, and earned critical acclaim, earning ten nominations at the Academy Awards, winning five, including Best Writing, Original Screenplay.

Even into her later years, Edith Wilson attended many events around the world celebrating and commemorating the legacy of her deceased husband. While she remained a respected figurehead in Washington society, Edith also valued personal privacy. There are no known voice recordings or transcripts from any interviews Edith may have given. She is seen here at the Federal Reserve, an agency President Wilson established.

Each year after Wilson's passing, Edith Wilson would attend the tradition of placing a wreath of red, white, and blue flowers on the burial place of the deceased president at the National Cathedral on the anniversary of their birthday. She is seen here at the National Cathedral on December 28, 1956, which would have been Wilson's 100th birthday.

Ten

THE MUSEUM'S COLLECTION

Edith Wilson called 2340 S Street her home until her death on December 28, 1961, which would also have been Woodrow Wilson's 105th birthday. She was 89. She is buried in the columbarium crypt, below Wilson's tomb at the Washington National Cathedral. She bequeathed the house and its contents—over 8,400 items —to the National Trust for Historic Preservation.

The Woodrow Wilson House opened to the public as a museum in 1963, a testament to the devotion and foresight of Edith Wilson in preserving this home for posterity. The museum staff takes their responsibilities seriously as stewards of this home, its garden, and its collections.

In addition, they have a responsibility to educate the public about President Wilson and his legacy. President Wilson and his administration were a bridge between the 19th and 20th centuries. His legacy includes the League of Nations, women's right to vote, the Federal Reserve System, and much more. The site also examines President Wilson's shortcomings, especially relating to race and civil liberties. An honest appraisal of history helps Americans understand themselves as a nation and as a people.

The museum is owned by the National Trust for Historic Preservation, which is a 501(c)3 nonprofit organization, open to the public year-round, accessible to all, and serves the community through public and private tours, exhibitions, and educational programming. Today, the Woodrow Wilson House looks at its mission from a historical perspective, strives for modern initiatives, and uses the site to learn about our complicated history and challenge ourselves about who we are as citizens of the world.

Edith Wilson bequeathed the Wilson House to the National Trust in a letter dated 1954. She remained living in the house until her death.

> August 14 – 1954
> 2340 S STREET, N. W.
> WASHINGTON, D. C.
>
> My dear Mr. Finley:
>
> I have just received your very nice letter of August 13th and want to thank you for your personal interest regarding the House as a memorial to Mr. Wilson — It makes me deeply content to know it will always

Edith Wilson died on December 28, 1961, and was interred in the National Cathedral. She had been expected to attend the opening of the Woodrow Wilson Bridge in Washington later that day as a guest of honor. It was also the 105th birthday of the man she loved deeply and who had been one of America's most consequential presidents.

> be preserved and taken care of —
>
> I hope I will soon have the pleasure of seeing you to thank you personally for your interest —
>
> Remember me warmly to Margie and with renewed appreciation believe me
>
> Faithfully
> Edith Bolling Wilson

One of Woodrow Wilson's prize possessions was Lincoln's life mask, now part of the Wilson House collection. For many years, Wilson was regarded as a preeminent leader of the United States, a visionary on par with Lincoln. Today, Wilson is seen as a complex, flawed leader, a human who strove for great accomplishments and whose policies were consequential.

Wilson's chair, cane, footstool, and illuminated globe grace the museum's library. Our mission is to preserve and steward the house, collections, landscapes, and its full and dynamic history, and use them to provide forward-thinking and inclusive discussions, programs, and community activities that are relevant today. The President Woodrow Wilson House invites the community to explore, engage, discover, and experience history.

BIBLIOGRAPHY

Berg, Scott. *Wilson*. New York: G.P. Putnam's Sons, 2013.
Cooper, John Milton, Jr. *Woodrow Wilson: A Biography*. New York: Alfred A. Knopf, 2009.
Link, Arthur S. *Wilson: The Road to the White House*. Princeton, NJ: Princeton University Press, 1947.
loc.gov
Miller, Kristie. *Ellen and Edith: Woodrow Wilson's First Ladies*. Lawrence, KS: University Press of Kansas, 2014.
navy.mil
Roberts, Rebecca Boggs. *Untold Power: The Fascinating Rise and Complex Legacy of First Lady Edith Wilson*, New York: Viking Press, 2023.
Wilson, Edith Bolling Galt. *My Memoir*. New York: the Bobbs-Merrill Company, 1939.

About the Organization

Why does the President Woodrow Wilson House matter? It is not merely a house-turned-museum; it is a destination that holds profound significance in the tapestry of American history. It serves as a beacon of remembrance, preservation, and education, carrying the legacy of Woodrow Wilson and his transformative presidency into the present and future.

This is a place that matters because it encapsulates the essence of Woodrow Wilson, an influential leader who guided the United States through a period of profound change and challenged the nation to embrace progressive ideals. As visitors step into the President Woodrow Wilson House, they are transported back in time, immersed in the atmosphere that once surrounded Wilson and his family.

The significance of this place lies in its ability to bridge the gap between past and present, providing a tangible connection to the ideals, struggles, and accomplishments of a remarkable leader. It also serves as a testament to the power of historical preservation, reminding visitors of the importance of learning from the past as they shape the future.

But the President Woodrow Wilson House is more than a historical artifact—it is a living museum, a dynamic space that fosters engagement, dialogue, and intellectual growth. Through exhibits, educational programs, and events, it invites visitors to explore, question, and reflect upon the complexities of Wilson's presidency and its relevance to contemporary society.

It is a place that matters because it embodies the spirit of democracy, inviting individuals from all walks of life to engage with history and contribute to the ongoing conversation surrounding the complex legacy of Woodrow Wilson. It encourages critical thinking, empathy, and a deeper understanding of the complexities of leadership, politics, and the impact of ideas on the world stage.

Moreover, the President Woodrow Wilson House matters because it is a reminder that history is not a distant relic, but a living, evolving force that shapes our present and future. It challenges people to confront the triumphs and the flaws of the past, encouraging learning from the past to create a more inclusive, equitable, and just society.

As visitors explore the President Woodrow Wilson House, they are invited to grapple with the complexities of Wilson's presidency, contemplate the choices he made, and reflect on the ongoing relevance of his ideas. It is a place that encourages dialogue, fosters understanding, and promotes an appreciation for the power of leadership and the enduring impact of individuals who shape history.

In a world that is constantly evolving, the President Woodrow Wilson House remains a steadfast reminder of the lessons and legacies that endure. It serves as a testament to the power of ideas, the importance of leadership, and the transformative potential of individuals who dare to envision a better world.

This is a place that matters because it is not just a house, but a beloved historic house, a home filled with stories, ideas, and inspiration. It is a space where the past is kept alive, where the legacy of Woodrow Wilson resonates, and where visitors can connect with the power of history to shape the present and inspire the future.

The President Woodrow Wilson House is a place that matters, and it invites everyone to be part of its enduring story.

Discover Thousands of Local History Books Featuring Millions of Vintage Images

Arcadia Publishing, the leading local history publisher in the United States, is committed to making history accessible and meaningful through publishing books that celebrate and preserve the heritage of America's people and places.

Find more books like this at
www.arcadiapublishing.com

Search for your hometown history, your old stomping grounds, and even your favorite sports team.

Consistent with our mission to preserve history on a local level, this book was printed in South Carolina on American-made paper and manufactured entirely in the United States. Products carrying the accredited Forest Stewardship Council (FSC) label are printed on 100 percent FSC-certified paper.